understanding color

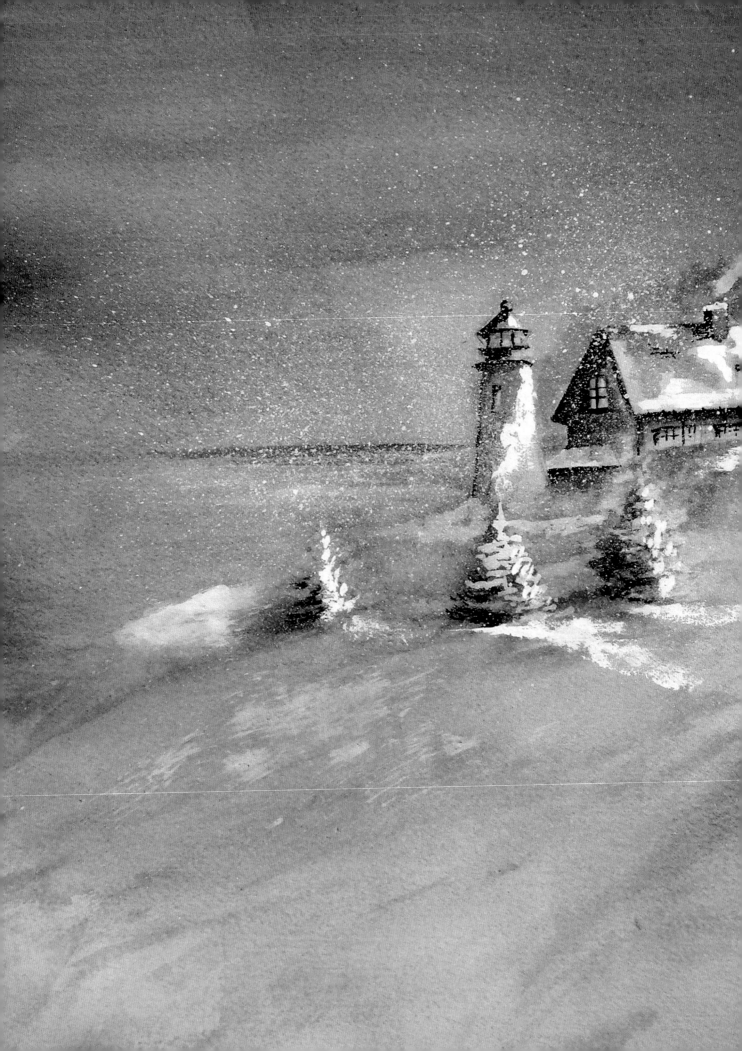

understanding
color

creative techniques
in watercolor

Marcia Moses

STERLING
New York / London
www.sterlingpublishing.com

STERLING and the distinctive Sterling logo are registered trademarks of Sterling Publishing Co., Inc.

Library of Congress Cataloging-in-Publication Data

Moses, Marcia.
 Understanding color : creative techniques in watercolor / Marcia Moses.
 p. cm.
 Includes index.
 ISBN-13: 978-1-4027-2574-6
 ISBN-10: 1-4027-2574-4
 1. Watercolor painting—Technique. 2. Color in art. I. Title.

ND2420.M67 2007
751.4'22—dc22 2007009099

10 9 8 7 6 5 4 3 2 1

Published by Sterling Publishing Co., Inc.
387 Park Avenue South, New York, NY 10016
©2007 by Marcia Swartz Moses
Distributed in Canada by Sterling Publishing
c/o Canadian Manda Group, 165 Dufferin Street
Toronto, Ontario, Canada M6K 3H6
Distributed in the United Kingdom by GMC Distribution Services,
Castle Place, 166 High Street, Lewes, East Sussex, England BN7 1XU
Distributed in Australia by Capricorn Link (Australia) Pty. Ltd.
P.O. Box 704, Windsor, NSW 2756, Australia

Book design and layout: Lori Wendin

Printed in China
All rights reserved

Sterling ISBN-13: 978-1-4027-2574-6
 ISBN-10: 1-4027-2574-4

For information about custom editions, special sales, premium
and corporate purchases, please contact Sterling Special Sales
Department at 800-805-5489 or specialsales@sterlingpub.com.

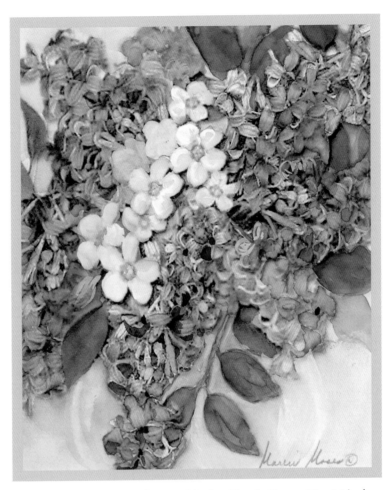

Lilacs and Posies, Marcia Moses, 11 x 14 inches

To my family for all their support of my goals:
"Thank you for believing in what
I was becoming even before it was clear to
see from a distance." —Anonymous

Contents

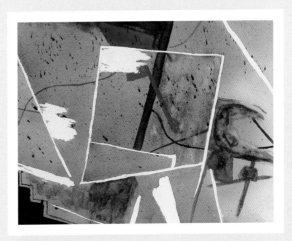

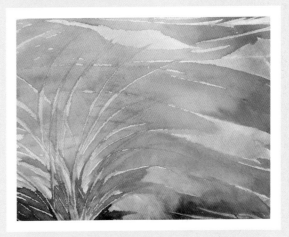

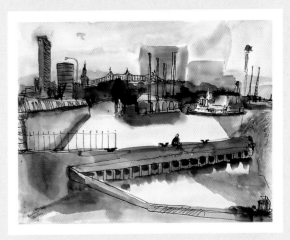

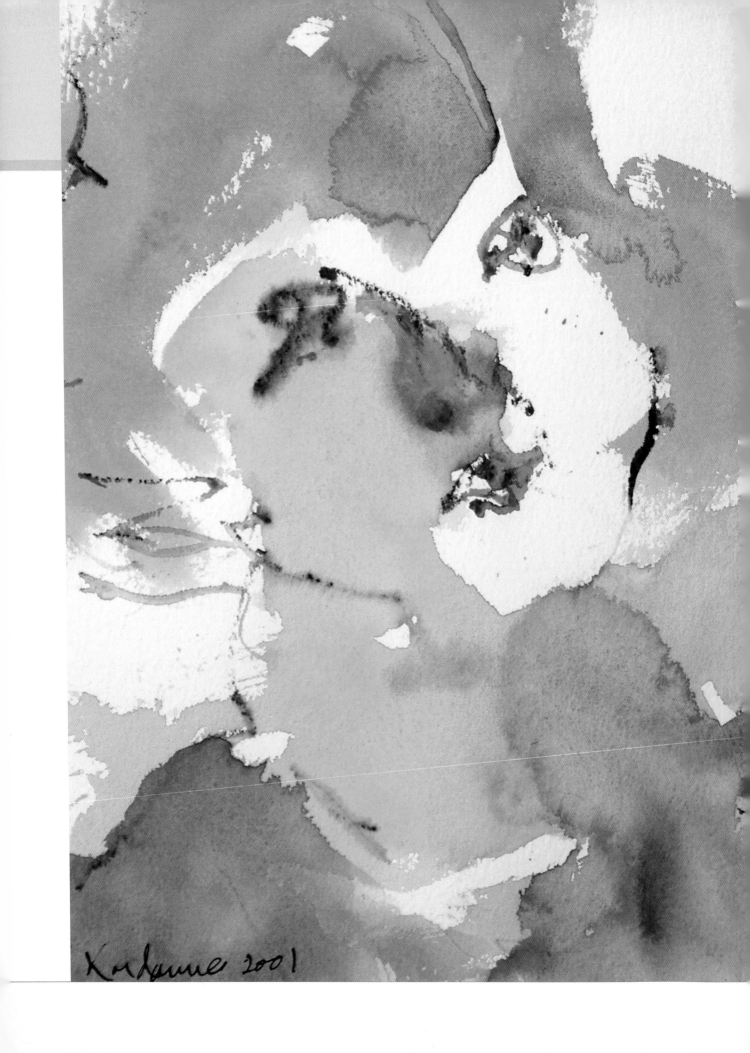

Kalianne 2001

Foreword

Serenity, Kris Wyler 13 x 120 inches.

left Marcia
Joe Kardonne
11 x 14 inches

MARCIA MOSES IS NOT SIMPLY AN ACCOMPLISHED
artist and instructor to students across the United States and
Canada, she is a visionary who cannot contain her passion for
art by capturing her visions on canvas alone. Her love of art
and color is not only evident in her paintings; it can be felt
in her teachings and seen in her eyes. Indeed, it hovers over
every conversation.

Marcia possesses the ability to see her surroundings as
we all should, through the enthusiastic eyes of a child who
wants nothing more than to share with the world the miracle
of a wildflower.

Her passion drives her to share this gift with others. She
strives to open the eyes of everyone who is willing to see. She
does not simply teach the methods and brushstrokes of
painting a still life, landscape, or portrait, but she also reminds
students to experience the miracle of nature and the natural
world as though they were seeing it for the first time. She helps
them express visually the beauty of everyday magic.

Throughout these pages, you will experience for yourself
the passion and excitement behind the techniques that Marcia
instills in her students. Her paintings will inspire you, and her
words will guide you through that inspiration so that you too
can turn your dreams and expressions into visual reality.

—*Laura Moses*

Let's Consider Color!

IT CAN TAKE MORE THAN A LIFETIME to learn everything there is to know about color. As Salvador Dali in *50 Secretos Mágicos* (1940), or *50 Secrets of Magic Craftsmanship* (English translation, 1948), said: "When you know all there is to know about a medium, ask an angel to sit on your shoulder and guide your hand." What he was trying to tell us is that we'll never be able to learn everything about color, but we can surely have a lot of fun trying.

Consider Leonardo da Vinci's writings, sculptures, inventions, and paintings. This master of many media was reported to have said on his deathbed that he had not finished learning. Every time we open a new tube of color, we are challenged to study and improve our work. An open mind, dreaming, reflection, and study will bring us a little closer to our goals. However, we cannot ever assume that we've mastered the seemingly infinite possibilities of working with color.

My students, who have had an insatiable desire to absorb each new lesson on color and its properties, have inspired this book. In these pages, I've tried to answer the many questions they've posed in my classes through the years. Each chapter and section has been organized to answer fairly specific questions and outline helpful techniques for applying watercolor. I've assumed that readers working in watercolor already understand basic design and painting techniques. These topics and more are covered in my first two books, *Easy Watercolor* (Sterling, 2002), and more intermediate techniques in *Creative Watercolor* (Sterling, 2005).

Why is it so important to understand color? When working with watercolor, if you do not completely understand individual color properties, you will not know what a particular watercolor will do on a piece of paper. That means that you will find it difficult, if not impossible, to compose and design with color. Eventually, you'll get lost as you paint.

Consider a color like rose madder. What are its properties? What makes it rose madder? What makes it so intense, and what does that intensity do to a painting? We will explore these and similar questions in these pages.

It's important to know what tools an artist uses; color is the most valuable. The aim of this book is to teach you to understand color and how to use it to the best of your ability in your artwork.

Often students will begin to brush color on paper, and then ask, "What do I do?" Knowledge of the properties of watercolor will help answer that question and others as well. Is a color grainy? Is it opaque or transparent? Is it luminous? Is it a staining color or one that can be "lifted" easily?

A part of that science of color (and it is a science) consists of breaking down each color and knowing its properties. Each time I teach a beginner's class, I lead my students through what may seem like a boring process, teaching them why colors work together or work against each other. They can use a solid foundation in color for the rest of their lives.

In this book, I'll begin to lay that same foundation, freeing you of your doubts about your ability to use color and allowing you to experience the jubilation of success through conquering the mystery of color theory. I will deal with a variety of aspects of color. We will explore the who, what, when, where, and why of color.

When you finish this book, you'll be able to identify certain colors and their properties and know how they'll react when applied to different types of paper. You will be able to build your own personal palette, collecting colors that you are comfortable using. And you will have learned how to design a painting with color, based on your knowledge of the color wheel. Welcome to a delightful journey. *Enjoy.*

History of Watercolor

Simply put, *watercolor* is a painting compound using water-soluble pigments that are either transparent or opaque.

Because of the medium itself as well as the paper to which it is applied, watercolor frequently is thought of as a fugitive medium, a fleeting one that will fade with age. Not so! While watercolor may not rival oils for durability and longevity, it is a medium that has a very durable and distinguished history and, clearly, a healthy future.

Watercolor painting, according to art historians, is one of the oldest forms of painting, dating from about 30,000 years ago. In Europe, early humans engaged in body painting, and shamans among them painted animal and human figures on walls deep inside caves. Watercolor was also used on ancient Egyptian papyrus rolls, the first real application to a medium resembling paper.

For the purist, "true watercolor" implies a method in which pigment first dissolved in water is applied to paper, which results in transparent washes. Many feel that for a paint or painting to be classified as watercolor, we must consider not only the paint's water solubility, but the techniques of applying that paint and the effects the paints produce on paper as well. This definition puts watercolor art in a completely different category than tempera, gouache, and acrylic; these water-soluble paints depend on methods of application that result in opaque finishes.

INVENTION OF PAPER AND DEVELOPMENT OF PAPERMAKING

While watercolor has been applied to papyrus, woods and barks, cloth fabrics, canvas, parchment and vellum, leather, and other media, the development of the painting technique we know today was closely tied to that of paper. In A.D. 105 in China, Cai Lun invented paper made from macerated plant bark, hemp fibers, and old fishnets put in a water suspension. About 300 years later, papermaking, located in the town of Tun Huang (Dunhuang), began to spread to other towns in China. Paper reached the Arab world as early as A.D. 707, and papermaking techniques arrived in the Middle East about A.D. 750 with Chinese prisoners of war. Egyptians began making paper using Chinese methods in about A.D. 900. Paper was imported and used in Spain in A.D. 950, Sicily in 1102, Germany in 1228, and England in 1309. The Moors introduced papermaking techniques to Spain,

and the first European paper mill was built in Xativa, Spain, in A.D. 1150. By 1268 a paper mill in Fabriano, Italy, that's still known for production of high-quality paper today, began operation.

In a parallel development, around A.D. 500 the Mayans were using a bark paper in Central America.

FROM THE RENAISSANCE TO TODAY

Before the popular use of watercolor paints on paper, *buon fresco* painting of murals or walls used watercolor paints on wet plaster. The Sistine Chapel ceiling (1508–1514) was painted by Michelangelo using this technique and was later fixed by a lacquer.

Albrecht Dürer (1471–1528) created some of the first enduring watercolors and influenced the first school of European watercolor, led by Hans Bol (1534–1593). Watercolor grew in popularity during the Italian Renaissance, but artists primarily used it in studies for later creating paintings with oils. Artists typically made pen-

and-ink drawings and added ink washes in varying color values to produce a sense of volume. In England, watercolor was first used by architectural draftsmen and topographers, who introduced figures into their compositions. By the 19th century, watercolor had become a medium that rivaled oils in England and on the Continent.

In America, Winslow Homer (1836–1910) revealed the extraordinary potential of watercolor as a medium of serious expression. After it was accepted, watercolor became an inevitable medium for 19th century American painters, particularly those creating landscapes, depicting early exploration of lands and Native American habitats in the West, describing flora and fauna, or recording history in the battlefields of the Civil War. Newspapers and magazines, such as *Harper's Weekly,* used watercolor drawings to illustrate news articles and stories. Watercolor's luminosity and capacity for rapid execution gave landscape painters an ideal means for recording the fleeting effects of nature.

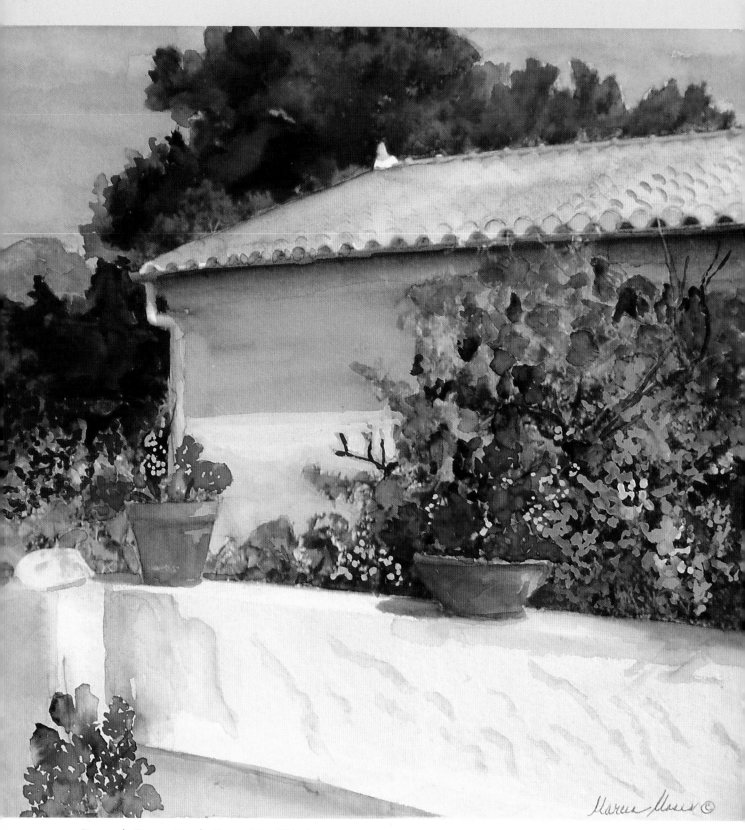

Romantic Greece, Marcia Moses, 15 x 19 inches

Introduction to Color

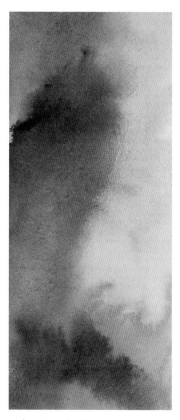

Color, Marcia Moses,
2 x 8 inches

Not Just the Old Grind

ARTISTS TODAY HAVE SO MUCH MORE TECHNOLOGY available to them than did the Old Masters. Modern artists don't have to grind their own colors or use any additives with paint, other than water.

Modern artists still cannot claim to have true primaries in their palettes, nor did painters from generations ago. Although some experts claim that the true primaries are magenta, cyan, yellow, and black (what printers prefer), these colors, when squeezed from a tube, are *biased* toward other colors. That means they have hints of those other colors in them. We can also call this an *undertone* (of a different color). Magenta has red plus a bit of blue, and cyan has blue plus a bit of yellow.

Therefore, to find a color that will work in our paintings, we need to study the particular paint color's characteristics and learn what that color will do when mixed with water or combined with other colors.

Perhaps the most important lesson to learn about watercolor is the need for a positive attitude when experimenting. Color theory is not easy, but it can be fun and can help you build self-confidence in your painting. Art naturally builds upon itself.

Watercolor materials include paints, brushes, and a palette.

When you understand what you need to do in terms of color to make a painting come alive, you'll soon be proud of your work.

Trying to produce just the right color can at times be frustrating. Not knowing all the characteristics of your paints is like a physician trying to diagnose a patient's illness without knowing how to use all the instruments in his bag. While understanding color is not as complex as curing a disease, it can be frustrating to both novices and professionals.

Choosing the Paper

When choosing from among the various types of watercolor paper available, artists need to consider many factors. Those experienced among you probably already have your favorite paper,

but sometimes it's helpful to look over someone else's shoulder, since a different paper can achieve differences in color.

Each kind of paper has its purpose. Naturally, the manufacturers want us to believe that their paper is the best. That cannot be true. Each watercolor paper type has characteristics that may appeal to different artists since it's appropriate for their techniques and finished artwork.

I have tried numerous types and brands of paper. I love to experiment on different kinds of paper, and I have become attached to a number of brands because of their versatility. Strathmore, for example, makes two papers I prefer, Imperial and Gemini. Strathmore Imperial has a smooth surface that is great for pouring and allows easy lifting of any undesired color. Strathmore Gemini is a cold-press paper that can be quite versatile.

Here are several varieties of watercolor paper.

Arches cold-press paper has a wonderful surface that allows the pigment to seep into the wells of the paper if you are using a wet-brush technique. Using a dry-brush technique, on the other hand, will cause the paint to skip over the wells, and create, for example, the effect of light sparkling on water. The paper also allows you to lift and move around the paint with a brush, knife blade, credit card, razor, or another ordinary household object to create a desired texture. Winsor Newton cold-press paper has similar properties.

Before choosing a paper, ask yourself what you are trying to achieve with a particular painting. If you are considering creating a landscape with lots of texture, for example, and you want the paint to skip across the page, then you need to use a rough paper with a dry-brush technique. The rough paper provides high areas on its surface on

its peaks, and the dry-brush technique prevents the paint from seeping into large wells of the paper, thereby giving allowance to the white of the paper.

- **Machine-made papers** come with three surfaces: *rough, hot-pressed or HP,* and *cold-pressed (or NOT).*

- **Rough paper** has a prominent tooth, or textured surface. This creates a grainy effect as pools of water collect in the larger indentations in the paper. Leaving the white of the paper and using a dry brush prevents the paint from seeping into the larger wells of the paper.

- **Hot-pressed paper** has a fine-grain, smooth surface with almost no tooth. Paint dries very quickly on it. This makes it ideal for large, even washes of color.

- **Cold-pressed paper** (NOT) has a slightly textured surface, somewhere in between rough

and hot-pressed paper. It's the paper watercolor artists most often prefer.

Paper differs from manufacturer to manufacturer, so experiment not only with the different kinds of paper but also with various paper brands. This is important because the paper can make or break a painting with lots of color. The thickness of watercolor paper is indicated by its weight, measured in grams per square meter (gsm) or in pounds per (uncut) ream. The standard machine weights are 190 g (90 lb.), 300 g (140 lb.), 356 g (260 lb.), and 638 g (300 lb.). Paper less than 356 g (260 lb.) should be stretched before use; otherwise, it will warp.

HINT FROM THE MASTERS

Impressionists mixed non-primary colors to create shadows and colorful grays. Complements, like red and green, make colorful grays.

Watercolor paper is usually white, but need not be. Varieties of cool and warm tints are available. Use acid-free paper for paintings you hope to keep because they will yellow less with age. Cold-pressed paper is called NOT, because it is *not* hot-pressed. (I'll never figure out why they don't simply call it cold-pressed.) You can buy prestretched watercolor paper in drawing blocks. After you have finished a painting executed directly on the paper on top of the block, use a palette knife to remove the top sheet from the block.

Color Attributes

Let's consider a twelve-part color wheel. *Primary colors*—red, yellow, and blue—are placed evenly around the circle. *Secondary colors*—green, orange, and violet—appear between the three primaries. They are mixtures of the two primaries

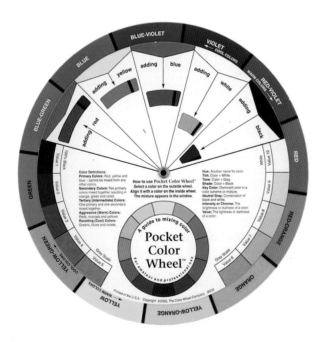
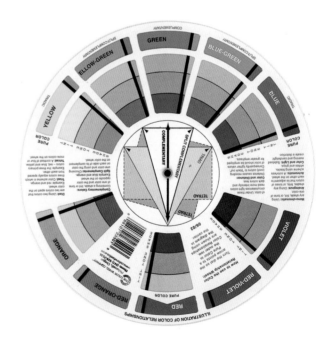

Color wheel (back and front) made by the Color Wheel Company.

Warm colors
are on top and
cool colors on
the bottom.

between which they sit. *Tertiary colors* are found between each primary and secondary color. Found between yellow and orange, for example, is yellow-orange. The color found between blue and violet is blue-violet.

Keeping these three basic kinds of color—the primary, secondary, and tertiary—in mind, we'll also be discussing complementary, saturated, and compound colors. *Complementary colors* are colors found opposite each other on the color wheel. Red and green are complements, blue and orange are complements, and yellow and violet are complements. *Saturated colors* are all these colors found around the outside of the color wheel. They contain no black, no white, and none of their complementary (or opposite) colors. *Compound colors* are colors containing a mixture of the three primaries. All the browns, khakis, and earth colors are compound colors.

In order to mix pigments into clean, saturated colors, it is necessary to include a warm and cool of each of the primaries in your palette. There is no such thing as a pure primary pigment. When mixing green, for example, choosing a cool blue such as cobalt and a cool yellow such as aureolin ensures there is no trace of red in the green. Using a warm yellow like cadmium or a warm blue such as ultramarine would introduce a slight trace of red into the green, resulting in a compound color.

TOURING THE COLOR WHEEL

Primary Colors As we said earlier, there are no true primaries. Therefore, we must know that we are using colors that have a bias toward another color, and we must be able to distinguish which colors they are biased toward.

It's easier to understand this color vocabulary by seeing and identifying parts of the color wheel.

Color Wheel We can arrange the colors of the visible spectrum into a circle called the color wheel.

cool yellow +
cool blue = green

Color Wheel

warm yellow +
warm red = orange

warm blue +
cool red = violet

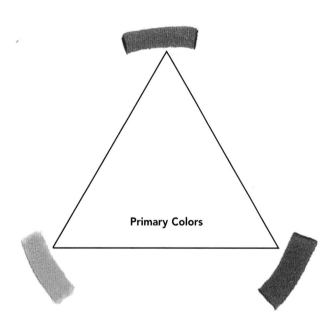

Primary Colors

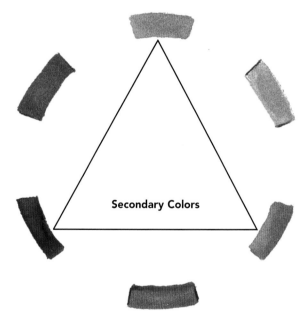

Secondary Colors

Primary Colors—red, yellow, and blue—cannot be made by combining other colors.

Secondary Colors are made by mixing two primary colors. Mixing red and blue, for example, gives violet. Secondary colors: orange, violet, and green.

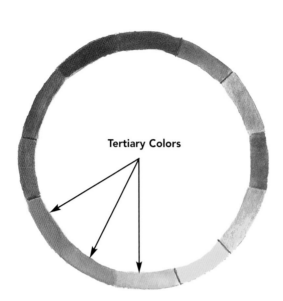

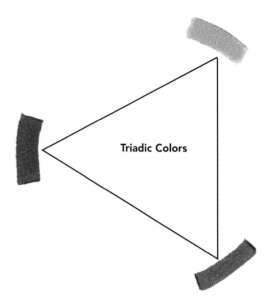

Tertiary Colors are adjacent to each other on the color wheel and are derived from mixing a primary and a secondary color. Mixing the primary color red and secondary color orange, for example, will produce red-orange. Mixing the primary yellow and the secondary orange will produce yellow-orange.

Triadic Colors form a triangle on the color wheel. They are, for example, red, yellow, and blue. Orange, green, and violet form another triangle, and so on.

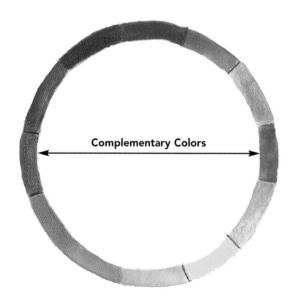

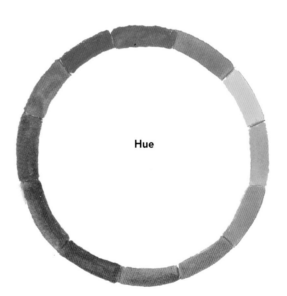

Complementary Colors are directly across from each other on the color wheel. Examples are red and green, yellow and violet. Red complements the color opposite it on the color wheel, green; yellow complements its opposite, violet, and so on.

Hue is the color in its purest form with no black, gray, or white added. For example, scarlet, crimson, and pink have the same hue—red. You can see hues on the outer edge of the color wheel and in the spectrum when mixed with water. Pink = Red + Water.

What are warm or cool colors? The color red may be warm or cool depending on the colors used to make it. If you are using the color rose madder as a primary, for example, you need to know that it is a cool red with a bias toward blue. By that, we mean it is closer to blue than to yellow. Some reds are biased toward yellow, which would make them warm colors.

Similarly, aureolin yellow has a bias toward blue, which makes it a cool yellow. Cobalt blue has a bias toward red; it is a cool blue. A warm blue, such as cerulean, would have a bias toward yellow.

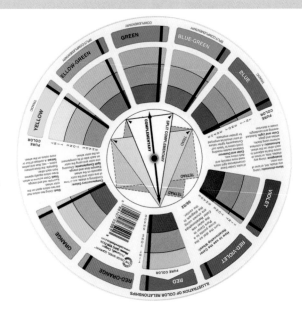

> **HINT FROM THE MASTERS**
>
> Paul Cézanne (1839–1906) modeled objects, giving them shape and volume by using patches of different colors.

Why be concerned about bias or undertone? When we talk about a color being biased toward another color, we cannot stress enough how important this characteristic is. Knowing a color's bias helps prevent artists from ending up with a muddy color when unwittingly mixing two colors that together contain all three primaries. (Red + blue + yellow = brown.)

You can begin to build a palette that suits your needs from a number of available primaries (reds, blues, and yellows). Remember that it is important to choose three primaries that work well together.

In a later chapter, we'll discuss and consider palettes used in various specific situations and learn why those palettes were effective.

Secondary Colors Remember that the secondary colors orange, green, and violet are represented in the color wheel on p. 10 as medium circles.

Secondary colors are derived from mixing two primaries. You can change the variations of the colors by changing the nature of the primaries. Again, knowing the characteristics of the colors on your palette will allow you to effectively mix colors that will contribute to the overall design of your painting.

Tertiary Colors Tertiary colors, remember, are the result of mixing a primary and a secondary color. If you mix the primary rose madder with the secondary orange, you will have the tertiary red-orange. Primary cobalt blue mixed with secondary violet = blue-violet.

Tertiary colors, identified on p. 10 by the smallest circles on the color wheel, are red-orange, yellow-orange, yellow-green, blue-green, blue-violet, and red-violet.

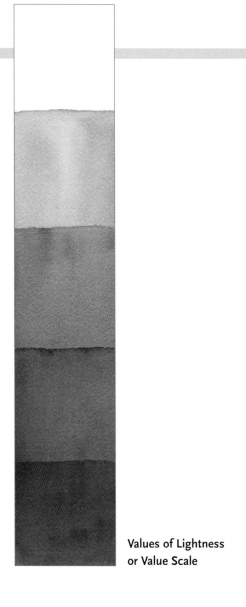

Values of Lightness
or Value Scale

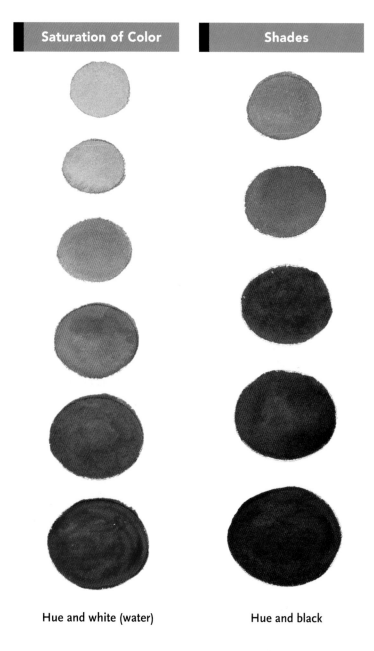

Hue and white (water)

Hue and black

More Terms About Color

Now let's step away from the color wheel and consider the use of color when painting with watercolors.

Lightness is the "blackness" or "whiteness" of a color. *Black* has a lightness of −1, *pure hue* has a lightness of 0, and *white* has a lightness of 1.

Saturation is the amount of hue in proportion to the neutral gray of the same lightness that is the intensity of color. In the example at right, the bottom circle swatch has the saturation of 1 (maximum value) and the uppermost swatch has the saturation of 0 (minimum value).

Shades are mixtures of a hue and black (hue mixed with complement). The example at far right shows five different shades of red.

Hue and white colors

Hue and complement or black

Color Tones with Complements

Tints are mixtures of a hue and white (water). The example at far left page shows five different tints of red.

 Tones are mixtures of a hue and its complement or grays. The example at left shows five different tones of red. The hues are mixed with various amounts of the complements to create colors ranging from a slightly dulled gray color to a black.

 Depending on the amount of color from the complement, the color can range from a darker red to black, which represents the three primaries used in equal proportions. For example, this happens because we start with a red that's biased toward blue, then add a green that's biased toward yellow.

COLOR AND DIMENSION

Without light, there would not be color, and without color, the world would be pretty dark and boring. However, we have color all around us, and as artists, we depend on the light to give dimension to objects, landscapes, flowers, portraits, and all the things we love to paint.

 Observe the apple. I want to show you how important tonal value is in creating dimension and making that apple believable. If the tonal value were not right, then the apple would appear flat. And with the wrong color tones, the apple could appear misshapen.

 There are five different tonal values on this apple: body tone, highlight, body shadow, reflection, and cast shadow. The overall tone of the apple is based on the lightest tone on the apple.

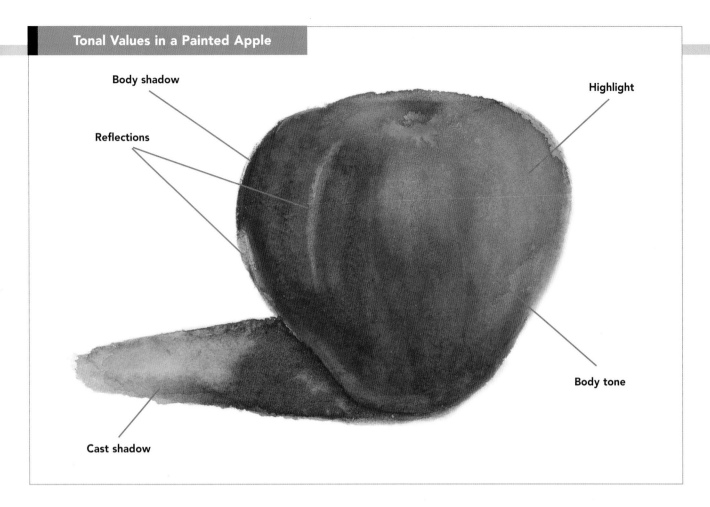

Body shadow

Highlight

Reflections

Body tone

Cast shadow

Notice the apple's body tone is lit on the right by the light source coming from the right. The highlight on the right comes directly from the light; it is the lightest tone of the color or the white of the paper. The body shadow appears on the left, where the light is partially hidden, and therefore, the shadow is a darker tone. The reflective tone found nearer the bottom left of the apple is a bit lighter than the body shadow.

The cast shadow is the darkest tone and appears on the surface on which the apple sits.

MIXING EXCITING COLORS

We love color so much that it may surprise us to realize that color does not actually exist in nature.

What we think of as a particular color is actually a distinct wavelength of visible light found in the electromagnetic spectrum. Each color has its own distinct wavelength. Red's wavelength is longest and violet's is the shortest. The other colors fall somewhere in between, generally with the lighter colors having the longest wavelengths. Ultraviolet radiation, with wavelengths shorter than violet light, and infrared radiation, with wavelengths longer than red light, are not visible.

The more you know about color, the more likely you are to mix colors that look more like waves of light than rivers of mud.

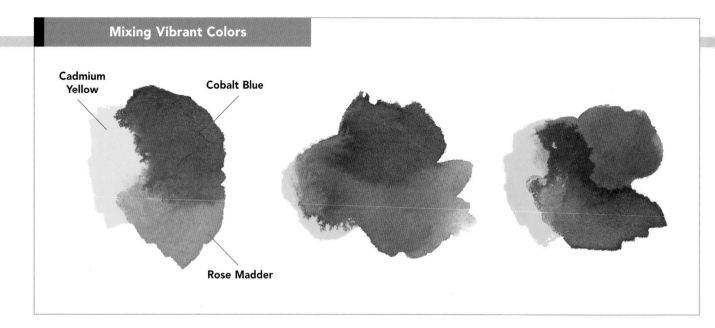

Cadmium Yellow

Cobalt Blue

Rose Madder

VIBRANT COLORS

Watercolors are the hardest paints to keep clean and bright because they often gray when mixed with colors that are incompatible. Unlike oil paint, which can be kept fresh and bright with many glazes or layers of color, it is difficult to apply one watercolor atop another without their interacting. Even if one color is dry, watercolors are more apt than oils to mix with each other on the paper, causing a graying effect, and thus losing the clarity and brightness of the original colors.

> ### HINT FROM THE MASTER
> Joseph Mallord William Turner (1775–1851) used fugitive reds in his paintings which in later decades turned dark or black.

The first rule for painting bright watercolors is to use only two or three colors in a mixture. Whenever you add a third color to a mixture, unless it is a tertiary color (those colors closest to the first two colors on the wheel), the mixture will be grayed down or even blackened.

For example, if you mixed a red and a yellow, then added a red-orange, your color mixture would remain within three tertiary colors. The mixture would retain its brightness. On the other hand, if you added a blue to the same mixture, you would lose the brightness. That's because the blue is the third primary. When we mix all three primaries, we will get a neutral or black, depending on the amount of blue added.

Another rule for keeping your colors vibrant is to make sure that the previous color is completely dry before you glaze with/on another color. How do you check to see whether the surface is completely dry? Test it with the back of your hand: If it is cool to the touch, it is still damp.

MIXING COLORFUL GRAYS

Gray can be a gloomy color that can produce unpleasant thoughts. It can make you remember rainy, chilly days with overcast skies.

That's perhaps why, early in my career as an artist, my use of neutral colors would dull my paintings. Without knowing why, I often darkened or neutralized the exciting colors in my paintings by using such colors as Payne's gray. My paintings were dull and lacked luminosity.

COLOR ABBREVIATIONS CHART

Alizarin Red	AR	Lilac	L	
Aureolin Yellow	AY	Madder Lake	ML	
Burnt Sienna	BS	Marine Blue	MB	
Cadmium Yellow	CY	Opera	O	
Cadmium Red Deep	CRD	Raw Sienna	RS	
Cadmium Red Orange	CRO	Rose Madder	RM	
Carmine	C	Royal Blue	RB	
Cerulean Blue	CrB	Shell Pink	SP	
Cobalt Blue	CB	Ultramarine Blue	UB	
Gamboge	G	Ultramarine Deep	UD	
Golden Deep	GD	Vermilion Hue	VH	
Hooker Green	HG	Viridian (green)	VG	
Lemon Yellow	LY	Yellow Ochre	YO	
Light Red	LR			

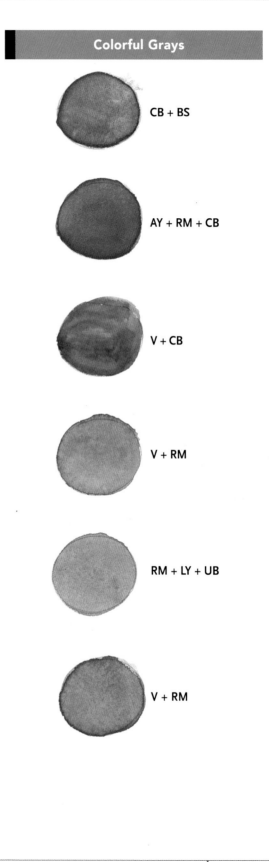

Colorful Grays

CB + BS

AY + RM + CB

V + CB

V + RM

RM + LY + UB

V + RM

Then I discovered that I could create my own more colorful grays by mixing all three primary colors in unequal proportion. For example, mix a primary yellow with a primary red in equal proportions to obtain an orange. Then add a tiny amount of primary blue to gray down the orange. The resulting gray, however, will be a colorful orangish-gray.

Suddenly my paintings took on life, and the only thing I had done was to eliminate Payne's gray from my palette. My paintings were more luminous and pleasing to the eye because I was mixing "primary grays."

To make colorful grays, there are a few other options you can explore. You can create grays not only from primaries, but also from complementary colors. You can lighten grays by diluting the color with water, or make them saturated for darker areas of a painting by using more of the pigment achieving a "darker black."

MIXING COLORFUL BLACKS

When you begin mixing colors to achieve colorful darks, however, you will quickly discover many ways to make mud, which will dull a painting rather than instill life in it. This is particularly a problem because we often need a dark color to complement another color that we'd like to stand out. On the other hand, we also need to fill in negative space behind an important shape in a painting with a dark color that will not merely take up space but add color to the painting.

Art-technique books advise us that we will get black or a muddy color when we mix three primaries together in equal parts or values. The reason we get a dull or muddy dark is that mixing the three primaries takes away all light from the spectrum, and we remove all color when we do this. The absence of light creates a dull effect. Colorists search for ways to solve this problem and still achieve a lively dark color that will not diminish the painting's luminosity, making it dull and uninteresting.

How do we get the right dark color? It helps to know everything about each particular color's properties and how it reacts with other colors.

Study each color as you make it a part of your palette so that you'll have an understanding of what that color will do on paper. If you do not know the chemicals you're working with and the science that makes them what they are, you're likely to become lost when you experiment with color. Mixing colorful blacks is much the same as mixing colorful grays. The difference is that you are using more saturated colors. You are mixing more pigment and less water.

I believe that we all have a preconception of what a color should look like, whether that color is black, white, yellow, or green. The fact that we all see color differently, however, would indicate that there are many different shades or tones of each color. Black, for example, is not always a dull or muddy color. It can be a black that contains a large amount of blue, green, or red, but it still will "read" as black.

Choosing Your Palette

You can set up your color palette a number of ways, but what I find most convenient is to separate warm colors from cool colors on your palette, whether it's round, square, or rectangular. This method has worked for me throughout the

Colorful Blacks

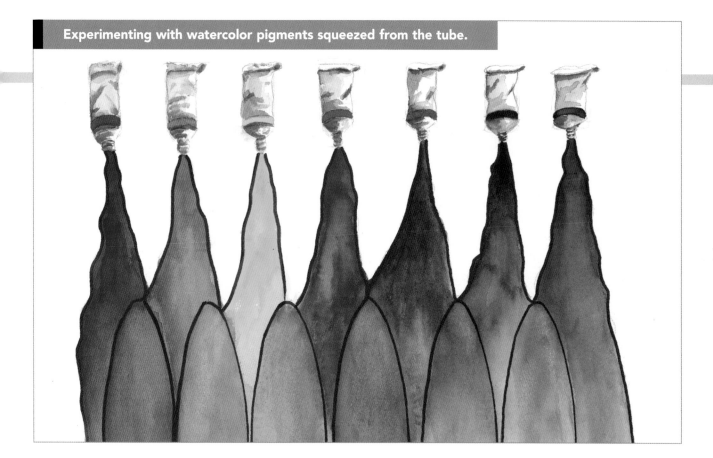

years I have been painting. As a rule, I use three different color palettes, sometimes four.

For my primary palette, I use a large plastic palette (Cheap Joe's Piggyback Palette) for my paints. This palette has deep wells for paint, a large divided mixing area, and a bonus palette for plein-air painting. It holds as many as 30 colors. While these are more spaces than I really need, the palette allows room for any new color with which I may choose to experiment.

The Robert E. Woods palette, on the other hand, has been my mainstay for years, and I still use it. Like Cheap Joe's palette, it has large wells for paint and a large mixing area, but does not offer the option of the plein air mini-palette.

I recommend Cheap Joe's Original Palette for easy travel. This palette is smaller and thus convenient to carry around in your paint bag. Because it seals tightly, it keeps the watercolors very moist, and holds all the colors I need when teaching workshops and does not take up a lot of room on the table. It is also great for students who may not yet be familiar with a variety of colors.

I also keep my Yarka palette available, primarily because it is a convenient travel palette and because it has two colors that I make great use of—Prussian green and red violet. Occasionally I use my butcher's palette, which is an open palette that provides a large space for freely mixing colors.

You'll discover numerous palettes on the market, and some of them conveniently allow the artist to arrange pigments with a purpose. Warm and cool colors, for instance, can be divided in such a way that you can easily distinguish the difference, thus making the mixing process easier.

It can be very confusing with so many options available. We all have different preferences in our painting supplies; these are mine after many years of experimenting.

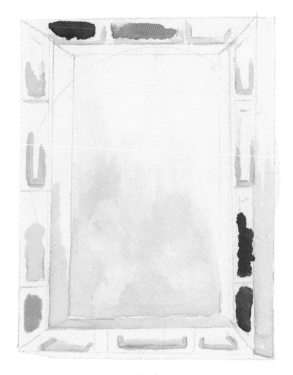

Cool Palette

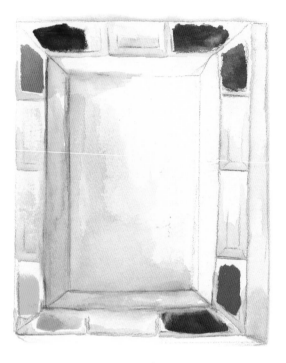

Warm Palette

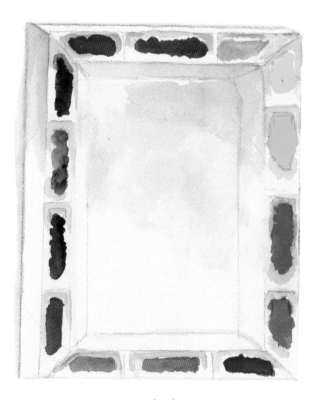

Mixed Palette

While I can recommend the many different colors I use, only you can decide what works for you. After you study color mixing and experiment with those colors and know what makes those colors act the way they do, then you can develop your own palette. Knowing how the color wheel works and why it works will also enhance your knowledge.

SETTING UP YOUR COLOR PALETTE

When you become familiar with the colors and their properties, you can start building your own palette according to your preferences. I have a number of different palettes depending on what I am doing at the time. There is a cool palette, a warm palette, and a mixed palette that has both warm and cool colors. I have learned over the years not to use colors that are fugitive. These colors fade over the years, and it is not worth the time and energy to use them and then lose them. Some manufacturers of alizarin crimson have a nonfugitive product. HK Holbein has alizarin crimson that will stand the test of time.

CHOOSING COLORS

After evaluating a number of different colors by numerous paint companies, I chose to be very consistent with the colors that worked for me. I often search for ways to make my paintings more luminous and striking. In this process, I have found the color palettes that meet these needs. I'll share that knowledge with you here and show you how to develop your own color palette.

In the process of discovering what works for you, you'll learn that we do not have the same likes

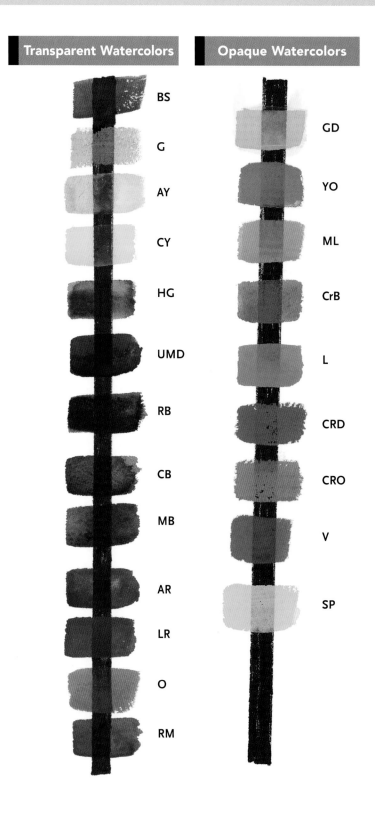

Transparent Watercolors	Opaque Watercolors
BS	GD
G	YO
AY	ML
CY	CrB
HG	L
UMD	CRD
RB	CRO
CB	V
MB	SP
AR	
LR	
O	
RM	

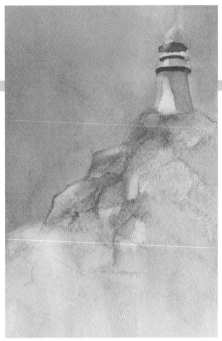
Painting with warm colors

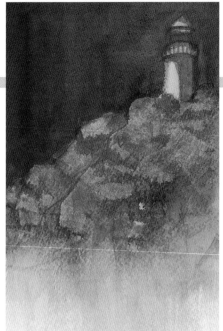
Painting with cool colors

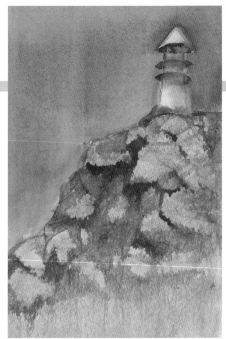
Painting with neutral colors

and dislikes. There's an understanding of watercolor that develops over time that will let you know that a certain color from a certain company will give you what you need to achieve your aims.

We'll also discover how the Old Masters used color to achieve such wonderful effects. These color secrets and your own work will help you set new, exciting goals for yourself.

EXPANDING YOUR PALETTE

When I began painting in watercolor, I bought every new watercolor I could find that looked appealing to me. Some of those original paints are now sitting in a box partially used and most likely dried up. A waste of money? Not necessarily; it was a learning experience that was very valuable.

I have found that I can do almost anything I want with about twelve colors (four sets of primary colors). If I need to use another occasional color, I simply apply a small amount of it on my palette at the time; that way, I have not wasted an entire tube of paint.

The palettes I have chosen to share with you will be helpful in making your decisions for you

in developing your own palette. Learning and studying the many different palettes of numerous successful artists is sometimes overwhelming, although in most cases it's stimulating. Study today's watercolor masters as well as the Old Masters from centuries ago. Most of those artists have given us a special gift with their insatiable desire to stimulate our souls. Keep in mind that colors are either *transparent* or *opaque*; the example below will be helpful in knowing whether the color you are using is one or the other.

By drawing a straight line with a permanent black marker, then applying a brush of paint over the line, you will be able to tell if the color is transparent or opaque.

COLOR FAMILIES

The color family you can choose can make your landscape look hot, cold, chilly, gloomy, rainy, dry, or frosty. Try drawing a landscape three times, and then color it with warm colors, cool colors, and neutral colors. You will see how color families can change the mood and visual temperature of your art.

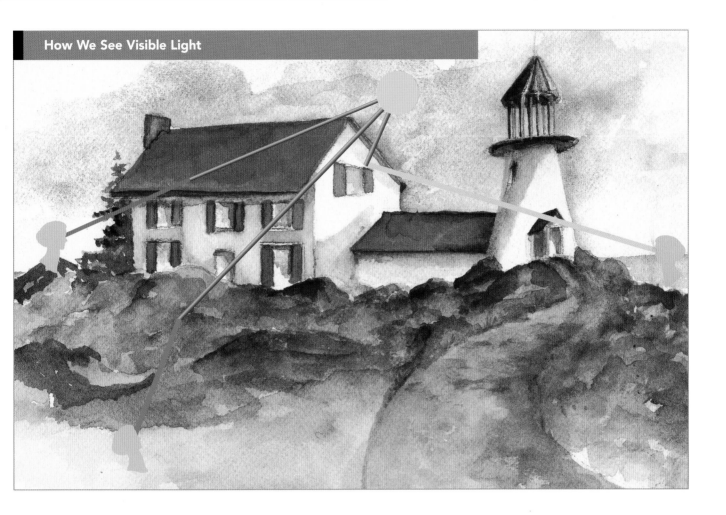

The colors of the visible light spectrum are red, orange, yellow, green, blue, indigo, and violet.

White light consists of all of the colors mixed together. The color of an object depends on how it either absorbs or reflects light. If an object absorbs all of the light wavelengths, it will appear black. If it reflects all of them, it will appear white. If an object absorbs all wavelengths except red, for example, it will look red.

Most color wheels do not display neutral colors or earth tones. Blacks, grays, and whites are neutral. Browns, beiges, and tans are sometimes neutral, too. As we have learned, *neutral colors* can be made by mixing black and white, complementary colors, or all three primaries together.

Very few watercolorists use black or white watercolors. Most prefer mixing primaries or complementary colors to create darks and shadows and use the white of the paper for white.

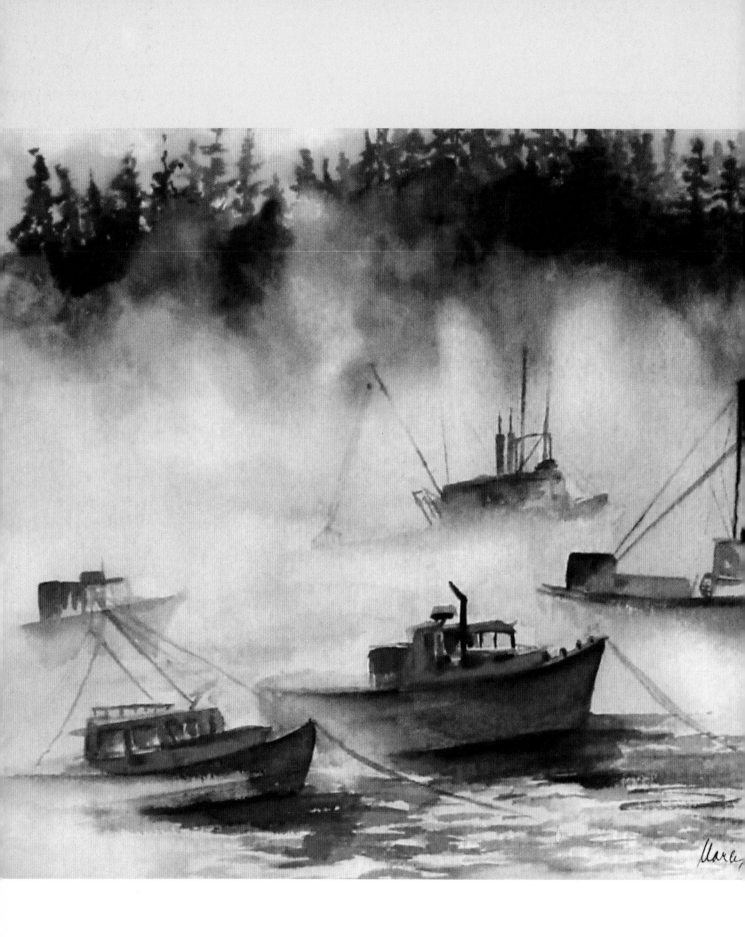

Color Effects

How We See Color

SUNLIGHT VARIES FROM ONE LATITUDE, ALTITUDE, and locale to another. Daily variations in sunlight change our perception of the world around us at different times of day, and the shadows we see vary by the hour if not by the minute. As artists we delight in these rhythms as much as we do in the ever-changing clouds, mists, rains, snows, and droughts. The seasons also change our perceptions.

As an artist, you cannot always paint in full-spectrum light that's color-wheel perfect. How you see the subjects you want to paint depends on the light that surrounds and bathes them. Indoors, under incandescent light, objects and human subjects enjoy a warm appearance with slightly yellow and red undertones. Fluorescent light imparts a slightly blue undertone.

Consider your subject. Under incandescent light, for instance, redheads and others with yellow undertone skin are flattered. The incandescent light suggests softness, but fluorescent light is decidedly unflattering and hardening to them. It highlights every flaw and blemish, brings out shadows unseen in natural light, and ages the subject by ten years or more. Most brunettes and others with blue undertone skin fare much better under fluorescent light

Fog in the Morning, Marcia Moses, 15 x 22 inches. Original painting.

and appear fairly natural, but incandescent light does not disfavor them. Nearly 80 percent of the population has blue undertone skin and appears attractive in cool colors. (Look at the inside of the wrist and consider the undertone independent of any pink, red, tan, or dark coloring.) Most African-Americans and Asians share this blue undertone as well, and cool colors and lighting also flatter them. Think of it as wearing the wrong colors for your complexion and coloring. Unflattering hues bring out all blemishes, while flattering hues are more forgiving.

Of course, everyone looks best in natural sunlight, or if truth is not desired, moonlight. Early morning light diffuses a room and appears rosy, while the setting sun diffuses slightly lavender light. Late afternoon light creates the best shadows and tends to produce warm and mottled colors. This is a great time for painting en plein air. Candlelight offers a gentle, warm glow that flatters most objects and people. Keep all this in mind when painting portraits as well as still lifes. Keep in mind that your watercolor pigments will also look somewhat different in changed light. Also be sure to remove any tinted lenses you might be wearing when viewing your subject(s) or choosing and mixing watercolor pigments.

Keep in mind that wall color and furnishings will create a mood and interact with the undertones of your subject.

You may have bought under the influence of department-store light what you thought was a red-orange item of clothing. After bringing it home, you discover that it was not the red-orange color you originally perceived. Then you wear it to the office, and the item becomes slightly burgundy under fluorescent light. Step outside and see what sunlight does to the color; then notice how it gradually darkens with nightfall.

Textile designers and weavers are aware of how adding a new hue to a fabric or design alters the appearance of other colors. Also, placing a woven fabric next to a distinct color alters the way we see and interpret its colors.

Light also affects how we see landscapes, cityscapes, and other outdoor scenes. Remember how Claude Monet (1840–1926), a master of color, painted Rouen Cathedral at various times of day under different light with each painting expressing a slightly different mood than the other. This series of paintings offers us an instructive narrative of light.

Color Theory, the Science of Optics, and Pointillism

Pointillism can help us understand how color works. This painting technique uses small dots of primary colors at points set very close to each other to create the impression of non-primary colors. It depends on "visual mixing" rather than the traditional method of physically mixing pigments on the palette or using a variety of color pigments sold in tubes or pans. This painting technique grew out of the mid-19th century science of optics and color. Viewed from a distance, viewers of a pointillist painting cannot distinguish the dots, which blend optically into each other.

Pointillists Georges Seurat (1859–1891) and Paul Signac (1863–1935), like other

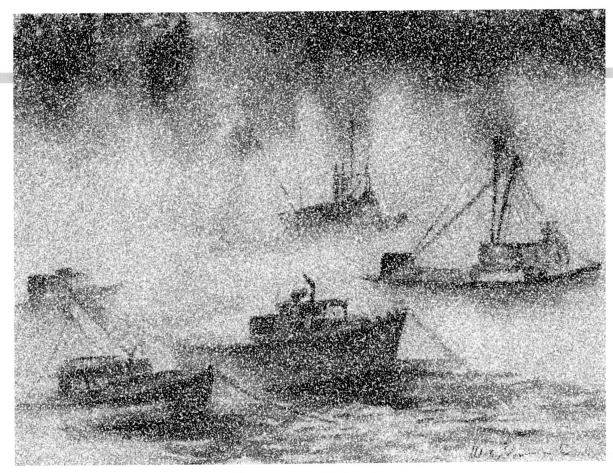

Fog in the Morning, **pixelated version created on computer with Photoshop.**

neo-Impressionists, probably read Charles Blanc's *Grammaire des Arts du Dessin* (1867), which describes how French chemist Michel Eugene Chevreul restored old tapestries at the Gobelins Tapestry Works in Paris. Chevreul found he could not produce the right hue of thread to make a repair unless he recognized the surrounding dyes. Two thread colors juxtaposed when slightly overlapping or very close together had the effect of another hue when seen from a distance.

Chevreul's theory of *simultaneous contrast* came in part from the observation that a certain black appeared different when placed next to blue. He also observed the effects of light and chiaroscuro that the artist repeats when reproducing nature closely. However, the use of color contrast meant that applying the paint's own color would exaggerate the color.

ADDITIVE AND SUBTRACTIVE COLOR SYSTEMS

Ogden Nicholas Rood took notes from the German physicist Hermann von Helmholtz to develop color theories and mixed juxtaposed material pigments. Rood's primary colors were red, green, and blue-violet. He postulated that two colors placed next to each other can be perceived as a third distinct color. He distinguished between the additive and subtractive qualities of color. He noted that optical (derived from light) colors (red + green + blue = white) and material pigment colors (red + yellow + blue = black) mix in different ways.

In *additive color,* light emitted directly from a light source, using red, green, and blue light, produces other colors. Combining these additive primary colors with another in equal amounts produces the additive secondary colors cyan,

magenta, and yellow. Combining all three primary lights—red + green + blue in equal intensities—produces white.

In *subtractive color*, material pigments, paints, dyes, inks, and natural colorants create colors that absorb some wavelengths of light and reflect others. The color produced is that part of the electromagnetic spectrum reflected by the particular object, or those parts of the spectrum not absorbed. That's why red + yellow + blue = black. This may be frustrating to painters, who must use material pigments, but understanding how color works means fewer surprises.

APPLYING COLOR THEORIES TO PAINTING

In the 1880s, Seurat developed a painting technique in which tiny brushstrokes of contrasting color portray the play of light. His thousands of tiny spots of color dotting the canvas create a shimmering effect that makes his paintings flicker with beautiful light and dreamlike haziness. It would seem that Seurat was ahead of his time.

Today we're familiar with the little dots called pixels (picture elements) that actually comprise three dots each with the red, green, and blue light that make up pictures or images on computer screens, whether LCDs or CRTs. What we see on a computer screen uses additive color (note description above) but demonstrates how these primaries can mix optically to create a wide variety of colors.

We've also seen the dots of printer's ink colors that compose the images in the Sunday comics.

These material (subtractive) colors—magenta, cyan, yellow, and black—can make up as many as 24,000 different colors on the printed page.

I experimented on the computer with Photoshop by pixelating one of my paintings with the pointillism tool. You can see how different the pixelated painting on page 29 looks compared with the original on page 26. This of course is just a rough approximation of what happens in pointillism.

YOUR TURN

Try out this dot technique to create shimmering effects isolated in selected parts of your paintings, say, for water. This technique probably works better with oils and other paint media than with watercolor. Experiment with paired dots of primaries (subtractive colors: red + yellow, red + blue, yellow + blue); then work with other dots of color. You may want the first color to dry before applying the second or third dot of color. Do a good deal of testing before you apply this to a painting.

Applying Your Knowledge of Color

Now that you have a basic knowledge of how color works, do you know how to apply that knowledge?

In my first color class in college, the professor was insistent that we learn how to use the color wheel. I believed at the time that this was so elementary. "Who doesn't know the color wheel?" I thought. Well, I found out just how much I did not know about color during that class. Learning

is an ongoing process. Artists cannot possibly learn everything about art in a lifetime. This is a good thing: challenge helps improve our art. Without that challenge, art could become boring, leaving us nowhere to go as artists and perhaps our creations would not even be considered art.

I fondly remember Helen Van Wyk, one of my favorite teachers, talking about artists who think they know it all. Essentially, what they are doing is shutting themselves off from their ability to learn. They stop learning and studying their art, and remove themselves from people who can offer them some of their greatest lessons.

As a teacher, I try never to assume that I know all the answers. I do answer every question I can, and when I do not know the answer, I try to research the question both for my students and for my own benefit. We all need to be humble and open-minded to grow. Don't deny yourself the privilege of questioning, and never assume that answers need to come from an instructor. Sometimes the most helpful lessons come from fellow students or artists. Also, don't dismiss what you may consider to be elementary knowledge; it can be good to refresh your understanding of basic concepts.

Remember, if we fail to question, we will not discover what's at the nub of a problem. Now let's begin to apply our knowledge of color to an artwork.

Ask yourself about the colors you are using, as well as about how those colors contribute to the composition and design of the painting in progress. Have you investigated all the possibilities that this color can provide? Is the color intense enough for what you want to

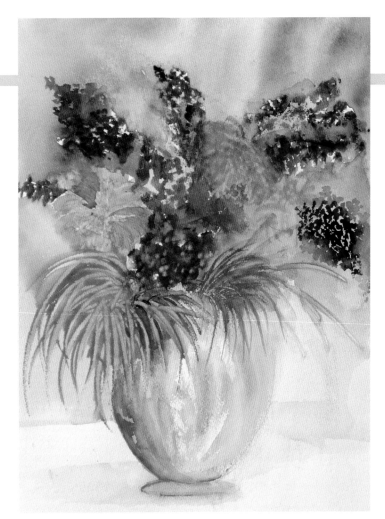

Floral Fantasy, Marcia Moses, 11 x 14 inches

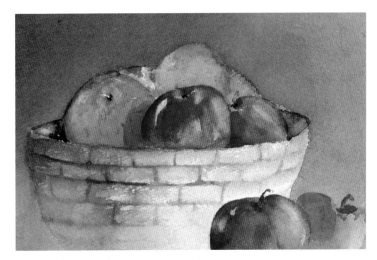

Fruit Basket, Marcia Moses, 11 x 14 inches

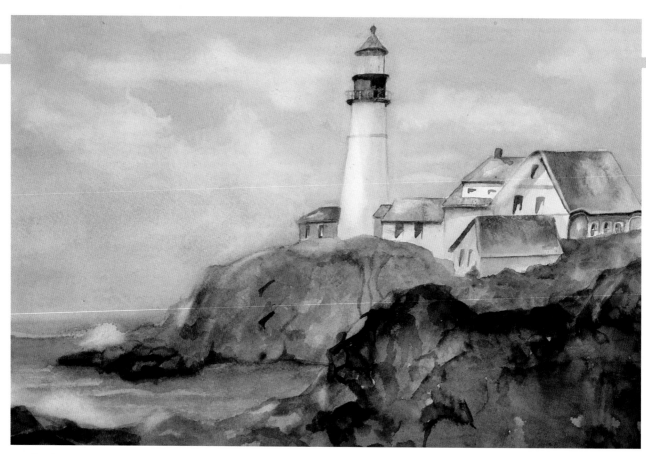

Portland Head Light, Marcia Moses, 22 x 30 inches

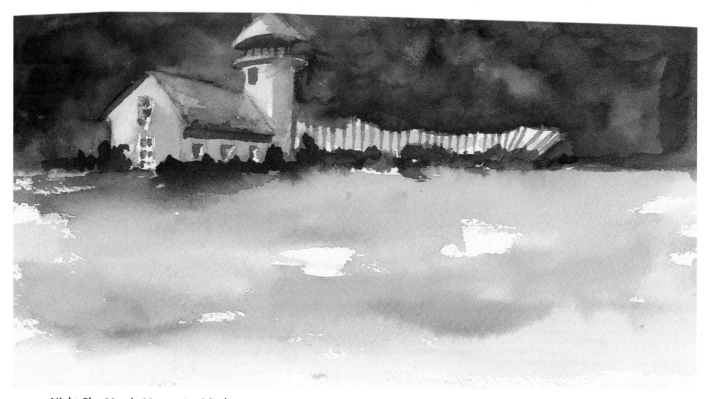

Night Sky, Marcia Moses, 4 x 8 inches

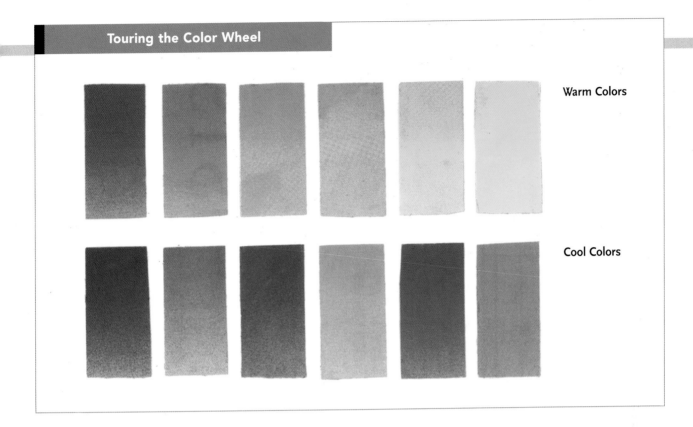

Warm Colors

Cool Colors

convey to your viewer? Are you telling a story with your painting? Are you listening to other artists who have stood the test of time? Have you chosen a plan for your painting? Have you chosen a color palette? Do you have a design in your mind? And what elements and principles of design have you chosen to tell your story on paper?

Warm and Cool Colors

When talking about color, I like to draw parallels with the seasons. Somehow that simplifies the way I think about color. Maybe this will also help you determine whether a color is warm or cool. In the summer, we think hot; so red, as the hottest color, would be appropriate for that season. Autumn has the oranges, yellows, red-oranges, and other warm colors. Winter brings the blues, violets, and dark greens along with the coolness of the season. Spring arrives and all the vibrant colors come anew, the greens more intense with the new growth of yellow daffodils, red tulips, and flowers in a variety of other warm colors. Therefore, if you think of summer as being hot and winter as being cold, then naturally the seasons in between fill in the spectrum presented in the color wheel.

The natural cycle of the seasons helps me break down the color wheel and construct appropriate color palettes for given subjects within my paintings. Use whatever works for you to see all things as being a part of nature and the natural cycle.

That having been said, we also need to remember that not all reds are warm. Some reds may have blue pigment in them, and of course, this would give these reds a bias toward blue

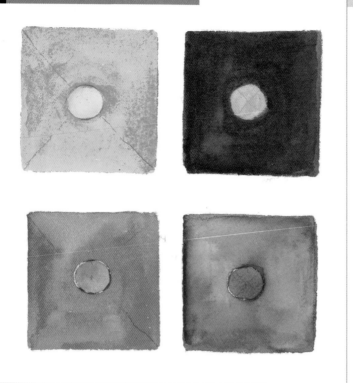

To learn more about what colors can do and become, mix gamboge, marine blue, and cadmium red in roughly equal parts. Add a little more yellow to that mixture and adjust the value with varying amounts of water. Then increase the amount of blue; see how the mixture becomes cool. Now increase the amount of red and observe how the mixture becomes warm. Play around with these mixtures until you have a feeling for achieving color balance and value, and for pushing color temperature.

Each color has a different meaning to the individuals who see it. In most of the Western world, a red light means stop, a green light means go, and yellow, caution. Therefore, we must keep in mind while painting that the colors we are using have connotations of their own.

Let's consider how colors whether found in artworks or in the world around us affect viewers. In a later chapter, we'll talk about contemporary availability and use of these colors in watercolor. First let's consider red in detail.

The Meaning of Color

RED

Red is an extremely dominant color; even a small amount in a painting draws your eye to it. It's the color associated with love, passion, anger, heat, fire, and blood. Of the various red pigments available to artists, each has its own characteristics and degree of permanency.

Art historians believe that ancient Egyptian artists introduced the first two reds suitable for painting. We still use them today. One is made

(a blue undertone). Therefore, they would be cool reds. That's why finding the properties of a color are extremely important.

Warm colors are hues associated with fire—red, orange, and yellow—while cool colors easily provoke thoughts of water, sky, or snow—blue, blue-green, or blue-violet.

Normally, warm colors appear to advance and cool colors appear to recede. If you place a cool violet against a warm yellow, it will create tension and cause the eye to see the yellow over the violet. Titian and Rubens made brilliant use of this principle.

Peter Paul Rubens (1577–1640) was an early master of analytical cubism, found in his sketches. He also deftly created a push-pull effect in his paintings of human figures. His use of color temperature brought his figures to life with action.

from cinnabar, a heavy, bright red mineral that constitutes the principal ore of mercury. The other red comes from madder root, the root of a perennial herb.

Many red pigments we can choose from are warm or cool, intense or subdued. Always keep in mind the fact that red appears to advance against a green or dark blue, which appears to recede.

Remember that red, the color of fire and blood, is associated with energy, strength, power, determination, passion, desire, and love. Red creates emotional intensity. Seeing it speeds human metabolism, increases the respiration rate, and raises blood pressure. Its very high visibility is why stop signs, stoplights, and fire equipment are usually painted red.

Red brings text and images to the foreground. Use it as an accent color to stimulate people to make quick decisions. In advertising, red evokes erotic feelings (red lips, red nails, etc). Red is widely used to indicate danger (high voltage signs, traffic lights) or to signify a prohibition, as in the universal sign with the red circle and diagonal line.

Numerous reds are available to modern artists.

Cadmium red comes in light, medium, and deep pigments; it is a very strong, warm, opaque red. However, cadmium red is also toxic.

Scarlet lake is a bright and intense red that has a slight bias toward blue.

Alizarin crimson is a dark, transparent, cool red with a slight bias toward blue or purple. Some manufacturers and artists believe this color is fugitive. Alizarin crimson is a synthetic pigment related to traditional rose madder.

Vermilion is a bright, intense red made from sulfur and mercury. It also is toxic.

Rose madder is a distinctive, transparent red made from rose madder root.

Indian red is a warm, dark, earth red with a bias toward blue. Although Indian red, derived from natural iron oxide, is a warm color, when mixed with other colors, it will become cool.

Burnt sienna is an earth-tone red.

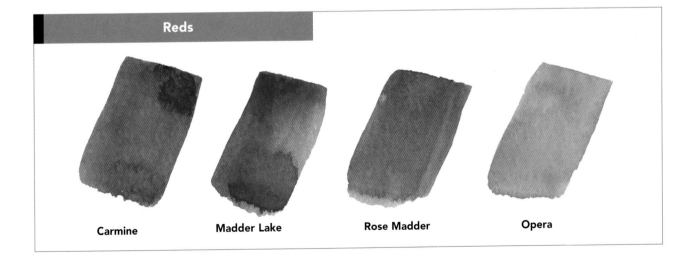

Reds

Carmine Madder Lake Rose Madder Opera

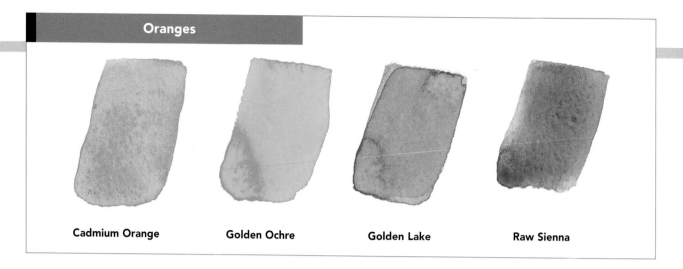

Cadmium Orange **Golden Ochre** **Golden Lake** **Raw Sienna**

Light red represents joy, sexuality, passion, sensitivity, and love.

Pink signifies romance, love, and friendship. It denotes feminine qualities and passivity. The color is calming.

Dark red is associated with vigor, willpower, rage, anger, leadership, courage, longing, malice, and wrath.

Reddish-brown is associated with harvest and autumn.

Brown suggests stability and denotes masculine qualities.

ORANGE

Orange combines the energy of red and the happiness of yellow. It is associated with joy, such as that felt when viewing a sunset. Orange represents enthusiasm, fascination, happiness, creativity, determination, success, and encouragement. Orange attracts the eye and stimulates the senses.

To the human eye, orange is a very hot color, so it gives the sensation of heat, although it is not as aggressive in mood as red. Orange increases oxygen supply to the brain, produces an invigorating effect, and stimulates mental activity. It is highly popular among young people. As a citrus color, orange is associated with healthful food and stimulates the appetite. As much as reddish-brown, orange is associated with autumn.

Orange has very high visibility, so you can use it to catch attention and highlight the most important elements of your design. Orange is very effective for promoting food products and toys. It is used for life vests and safety equipment.

Dark orange can suggest deceit and distrust as well as ambition. It can stimulate appetite and make people restless, which is why some fast-food restaurants choose it to gain rapid turnover of customers.

Red-orange corresponds to desire, sexual passion, pleasure, domination, aggression, and thirst for action.

Gold, made from orange and yellow with a touch of blue, evokes prestige. The meaning of gold is illumination, wisdom, and wealth. Gold often symbolizes high quality. It is associated with the precious metal.

YELLOW

Yellow is the perceived color of sunshine. It is associated with joy, happiness, intellect, and energy.

Yellow produces a warming effect, arouses cheerfulness, stimulates mental activity, and generates muscle energy. Yellow is often associated with food.

Bright, pure yellow is an attention-getter; taxicabs are painted bright yellow for this reason. Since yellow is highly visible when placed against black, this combination often is used to issue a warning.

Use yellow to evoke pleasant, cheerful feelings. Yellow is very effective for attracting attention; use it to highlight the most important elements of your design.

When overused, however, yellow may have a disturbing effect. Studies show that babies cry more in yellow rooms. In Western culture, yellow has also traditionally symbolized cowardice.

Men usually perceive yellow as a very light-hearted, childish color, so yellow is not likely to be used when selling prestigious, expensive

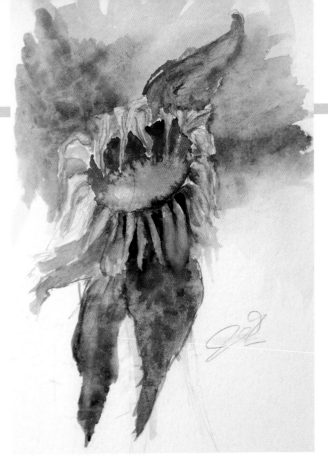

Sunflowers, John Moses, 14 x 22 inches.

"How wonderful yellow is. It stands for the sun."
—*Vincent Van Gogh*

products to men—few men will buy a yellow business suit or a yellow Mercedes.

Yellow is an unstable and spontaneous color; avoid using yellow if you want to suggest stability and safety. Because light yellow tends to disappear into white, it usually needs a dark color

Yellows

| Cadmium Yellow +
Lemon Yellow | Cadmium Yellow | Yellow Ochre | Lemon Yellow |

Viridian Emerald Green Prussian Green Raw Umber

to highlight it. Shades of yellow can be visually unappealing because they become dingy and therefore lose their natural cheerfulness.

Dull yellow represents not simply caution but decay, sickness, and jealousy. Like many opaque colors, this color tends to dull the senses.

Light yellow, however, is associated with intellect, freshness, and joy.

GREEN

Green, the color of nature, symbolizes growth, harmony, freshness, and fertility. It evokes strong emotional ties to safety.

Green has great healing power. It is the most restful color for the human eye; it can improve vision. Green suggests stability and endurance. Sometimes green denotes lack of experience. As opposed to red, green means safety; it is the color of free passage in road traffic. It can also be associated with ambition, greed, and jealousy.

Dark green is commonly associated with money or wealth.

Yellow-green can indicate sickness, cowardice, and discord as well as jealousy.

Aqua is associated with emotional healing and protection.

Olive green, as in the olive branch, is the traditional color of peace.

BLUE

Blue, the color of the sky and sea, is associated with depth and stability. It symbolizes trust, loyalty, wisdom, confidence, intelligence, faith, truth, and heaven.

Blue produces effects beneficial to the mind and body. It slows human metabolism and produces a calming effect. Blue is strongly associated with tranquility and serenity.

In paintings, blue can produce a clean effect. It also stands well for air and sky or water and sea. As opposed to emotionally warm colors such as red, orange, and yellow, blues suggest consciousness and intellect. According to color studies, blue is considered a masculine color that is highly accepted among males.

Blues

Ultramarine Cobalt Light Prussian Blue Marine Blue

When used together with warm colors, such as yellow or red, blue can create high-impact, vibrant designs. For example, blue-yellow-red is a perfect color scheme for a superhero.

Light blue is associated with health, healing, tranquility, understanding, and softness.

Dark blue represents knowledge, power, integrity, and seriousness. It is associated with depth, expertise, and stability. Darker blues indicate more depth than lighter blues.

VIOLET

Violet combines the stability of blue and the energy of red. It is associated with royalty, and symbolizes power, nobility, luxury, and ambition. It conveys wealth and extravagance. Violet is also associated with wisdom, dignity, independence, creativity, mystery, and magic. Because violet is not as common as other colors in nature, some people consider it artificial.

Light violet is a good choice for a feminine design. Light violet evokes romantic and nostalgic feelings. Little girls favor lavenders and pinks.

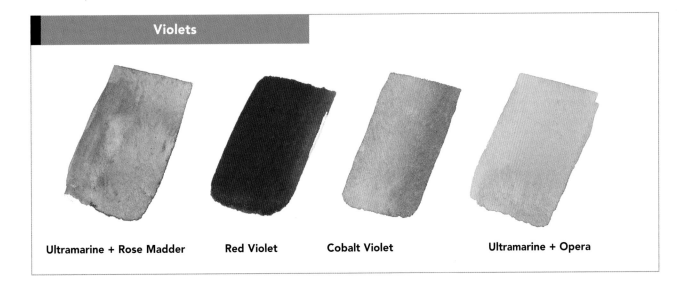

Violets

Ultramarine + Rose Madder Red Violet Cobalt Violet Ultramarine + Opera

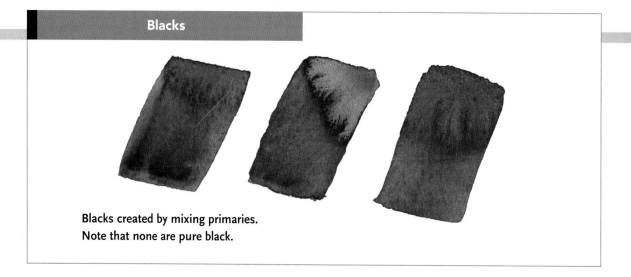

**Blacks created by mixing primaries.
Note that none are pure black.**

Dark violet evokes gloom and sad feelings. It can cause frustration.

WHITE

White is associated with light, goodness, innocence, and virginity. It is considered the color of perfection.

White suggests coolness, safety, purity, and cleanliness. It carries positive connotations. White can indicate a successful beginning. We usually imagine angels to be wearing white clothes and to have large, bright white wings. The color is thought to represent what's "good." It also suggests a blank, a clean slate.

BLACK

Black is associated with power, elegance, formality, death, evil, and mystery.

This color is also connected with fear and the unknown (for example, black holes). It can carry negative connotations (blacklist, black humor). Black denotes strength and authority; it lends elegance and prestige (black tie, black Mercedes).

Black gives the feeling of perspective and depth, but a black background diminishes

readability. A black suit or dress can make the wearer look thinner. Combined with red or orange—other very powerful colors—black establishes an aggressive color scheme.

Color Properties of Selected Watercolors

Rose Madder Natural dyes from madder plants include dozens of hydroxyanthraquinones. They make some of the most stable natural pigments.

The ancient Egyptians used rose madder, made from the crushed root of the common madder plant *Rubia tinctorium*, as a textile dye. The word *madder* is an 11th century Old English name for the local dye plant, later attached to the imported plant. Red and rose-madder lakes have also been found in Roman archaeological sites. According to Galen, a second century Greek physician, madder was used to treat jaundice.

The roots of the madder plant contain the acid ruberthyrin. When the roots are dried, fermented, or treated with acids, they are changed to sugar,

alizarin, and purpurin. Purpurin becomes red when dissolved in alcalic solutions. When mixed with clay and treated with alum and ammonia, this creates the brilliant madder lake.

The lakes are very lightfast.

Carmine (Crimson) Natural organic dye, also called crimson lake, that is made from the dried bodies of the female cochineal insect *Dactylopius coccus*, which lives on various cactus plants. It is mixed with tin or aluminum to form the pigment. It is also known by its chemical names, carminic acid (red glucosidal hydroxyanthapurin) or kermesic acid, a substance that inhibits other creatures from eating it.

The kermes insect, from which the pigment also derives, is an Indo-European cousin of the cochineal. While chemically related, it has a weaker concentration of the color. In Sanscrit the name was *krim-dja,* or our modern words *carmine* and *crimson.* The insect was described by the Greek physician Dioscorides in the first century A.D. in *Materia Medica* as a "coccus" (berry) as well as a grain or small worm. His observations were of course confusing to later generations.

Carmine is not permanent and may deteriorate under light, particularly when used in watercolor.

Vermilion (Cinnabar, or Cinnabar Vermilion) The word *vermilion* derives from the French *vermeil,* originally a cochineal

dye once thought to come from a little worm (*verme*). Today vermilion is known as the manufactured form of cinnabar; it is more resistant to blackening or fading.

In a popular ancient Roman tale, cinnabar was purportedly made from the blood of a dragon and an elephant. Pliny said that the two were always fighting. The dragon wrapped its coils around the elephant and killed it. But when the elephant fell, it crushed the dragon, which also died. Their merged blood made cinnabar.

Cinnabar was used in ancient Pompeii for fresco painting, notably in the Villa of the Mysteries at Pompeii and has been called Pompeii red. Imported from Almaden in today's Spain, the pigment was purified, synthesized, and ground to the correct fineness. If handled improperly, it could turn black. The fresco was coated in wax for protection.

The Romans painted gladiators with it and women used a lipstick made from it.

Cinnabar, a warm red, was made from mercury sulfide; mercury can be toxic. Today most painters use cadmium red, which is made from cadmium sulfide. This orangey red pigment has good permanence.

HINT FROM THE MASTERS
Wassily Kandinsky (1866–1944) used striking color to define the center of interest that drew the viewer's eye into the painting.

Cadmium Yellow Cadmium sulfide can be made in various shades ranging from very light yellow to deep orange.

The German scientist Friedrich Stromeyer accidentally discovered cadmium in 1817. The metal cadmium is often found together with zinc in natural deposits and has many chemical similarities to zinc.

It has very high hiding power and good permanence.

Indian Yellow This pigment was once produced by collecting the urine of cattle that had been fed only mango leaves. The practice stopped because it was thought inhumane. The chemical name is condensed azo pigment, diazo pigment. Today Indian yellow is made from urea, a synthetic pigment not from animals.

Lemon Yellow (Yellow Ultramarine, or Steinbuhl Yellow) This bright yellow pigment is made from barium chromate. It is a stable yellow with low hiding power.

Aureolin (Cobalt Yellow) A pigment used in oil and watercolor painting was once called cobalt yellow. It was discovered in Germany by N. W. Fischer; its chemical composition is potassium cobaltinitrite. This pigment has a mustardy top tone but a vivid golden undertone. This is an excellent glazing color.

It is one of the only transparent yellows that is reliably lightfast, and it mixes slightly to the greenish.

This replaced the earlier pigment gamboge, a yellow gum from Asia used until the late 19th century. In the 20th century cadmiums were introduced that were cleaner and more lightfast than aureolin. Golden aureolin hue was a blend of three yellow pigments of hansea and oxide; it could allow bright mixing without becoming too acidic.

Yellow Ochre This golden yellow or yellow-brown pigment is made from a natural mineral consisting of silica and clay and owes its color to hydrated iron oxide. It is found throughout the world, in many shades, in hues from yellow to brown and faint blue. The best brown ochre comes from Cyprus. There is also red ochre.

The ground ochre is washed to separate it from sand, then dried in the sun and sometimes burned.

Ochre was one of the first pigments used by humans. Hematite was used as crayons in France and Czechoslovakia over 300,000 years ago. It was also found in Neanderthal grave sites.

The pigment has good hiding power and excellent permanence in all media.

Cerulean This soft, comforting blue, biased toward yellow, is wonderful for skies and when mixed with a touch of red for certain skin tones. Its chemical composition is cobalt stannate, a compound of cobalt and tin oxides. The color is stable and can be easily lifted.

Marine Blue This blue is biased toward yellow. Its chemical composition is copper phthalocyanine. When mixed with burnt sienna, an earth tone, it creates beautiful greens and browns and can produce a colorful black, depending on how much burnt sienna you add. It is very staining and a stable color that is not easily lifted.

Cobalt Blue The pigment is made from cobalt salts. It is cobalt (II) oxide–aluminum oxide or cobalt aluminate. Production began in France in 1807 and was considered a good substitute for ultramarine. *Cobalt* is the German word for goblin or gremlin; it was so named because arsenic was frequently found close to cobalt when it was mined.

The greenish blue pigment is very stable and lightfast with limited hiding power.

Prussian Blue This dark blue is often called the first of the modern pigments. Prussian blue was discovered in 1704 by Diesbach, who was going to make carmine lake (from ground-up cochineal, alum, and ferrous sulphate, precipitated with alkali). By mistake he distilled it with animal oil instead of alkali. He found blue instead of red in his flask. The iron from the animal oil caused a chemical reaction, creating iron ferrocyanide, later called Prussian blue.

Today the pigment is made by adding a solution of iron (III) chloride to potassium ferrocyanide; when later dissolved in water, oxalic acid is added. The pigment was once used in early blueprint and photocopy processes.

It has very high tinting strength but is only fairly permanent to light and air.

Ultramarine A deep blue paint made originally from the semiprecious stone lapis lazuli, found in Afghanistan, Zambia, Serbia, and Chile. The Italian term *oltramarino* means "from beyond the seas." Chemically it is a complex of double silicate of aluminum and sodium with some sulfides or sulfates. It occurs in nature as a component of lapis lazuli. It was also once known as *azur d'Acre* and *azzurrum transmarinum,* among other names. It is the most complex of mineral pigments.

Ultramarine was used in seventh century cave paintings in Afghanistan, in 10th century China, and in Indian murals dating from the 11th century. Ultramarine pigment was the most expensive with the exception of gold, used in the Renaissance.

This pigment is transparent, nonstaining, easy lift, intense, and granulating.

 Indigo This pigment was prepared from plants until the end of the 19th century. Since 1870 it has been manufactured synthetically. The origin of indigo is the woad plant (*Isatis tinctoria*). In earlier centuries the pigment was obtained from the Mediterranean sea snail.

Until the end of the 16th century, indigo was considered one of the only sources of blue dye in Europe. Other blue dyes or pigments were imported.

It has fair tinting strength and may fade rapidly when exposed to strong sunlight.

 Burnt Sienna This rich rust color combines all three primaries. You can create it by mixing rose madder and aureolin yellow with a tad of ultramarine blue.

The chemical composition of the pigment from tubes is from native earth iron oxide (ferric oxide). It is a form of limonite clay. This naturally occurring pigment was one of the first pigments used by early humans for paintings found in caves.

The name originates from that of the town of Sienna, Italy, found in Tuscany, where the mineral was mined. Raw sienna is an earth color, and burnt sienna is heated raw sienna. Heating removes the water from the clay and reddens (to an orange-rust) its more earthy brown color. Its chemical cousins are ochre and umber.

Today many rust-colored tile roofs in the town of Sienna bear this color. With water added in painting, burnt sienna creates lovely beaches and fall leaves and looks well when adjacent to ultramarine. This color is transparent, nonstaining, granulating, permanent, and stable. The watercolor can be lifted.

 Green I mix my own greens often using marine blue and burnt sienna. You can also achieve beautiful browns with this mixture. I also like using Russian green (Yarka), which is richer than but similar to Prussian green.

Toxic Pigments

It's important to know the chemical formulation of pigments you plan to use and to read all the manufacturer's materials about them. It's impossible to list here all possible cautions.

Through the centuries, artists have been at risk for neurological and physical illnesses through their contact with paint paraphernalia and pigments, which could be absorbed through the skin, accidentally ingested, or inhaled. Therefore, it's important to paint in a well-ventilated room, preferably with open windows.

Emerald green pigment, once called Paris green, was Cézanne's favorite pigment and was

heavily used by other 19th century artists. Arsenic poisoning comes from the vapors emanating from the finished paint. Cézanne developed severe diabetes, a symptom of chronic arsenic poisoning. Monet's blindness and Van Gogh's neurological disorders might have been related to their use of emerald green as well as lead pigments, mercury-based vermilion, and solvents such as turpentine.

Another pigment popular with the Impressionists, cobalt violet was once formulated with arsenic. It has since been reformulated as light cobalt violet, with ammonium, and as deep cobalt violet, without ammonium. Other colors have been similarly reformulated.

Also remember that because pastels are mixed with chalk and oil, they can be very toxic. That's because they are powdery and soft and can be absorbed by the skin and one can also breathe in the minute dust particles. Use care when using any kinds of paints.

The Effects Colors Have on Each Other

Every color has an effect on another color; for example, if you place two complements beside one another they will enhance each other. Mixing two primaries will create a secondary color; layering three colors can produce a pleasing effect for backgrounds. There are many ways that colors affect one another. Here are just some of the many possibilities for creating color effects.

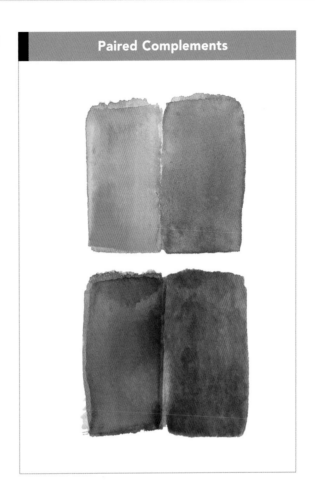

Paired Complements

Two Primaries

Mixing Vibrant Colors

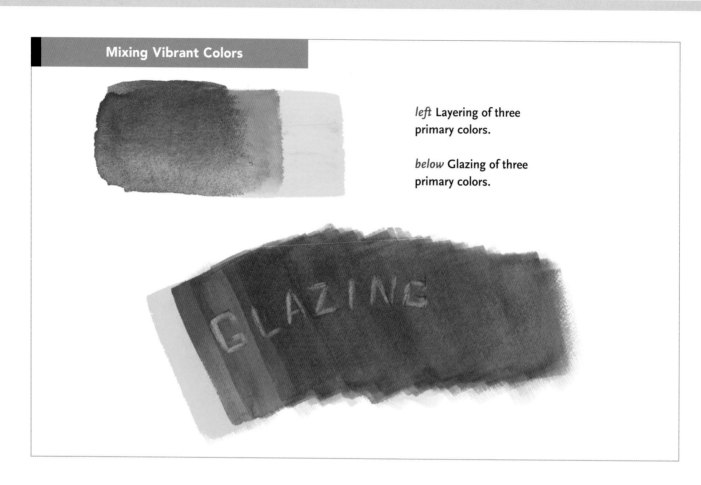

left Layering of three primary colors.

below Glazing of three primary colors.

Granulating Colors

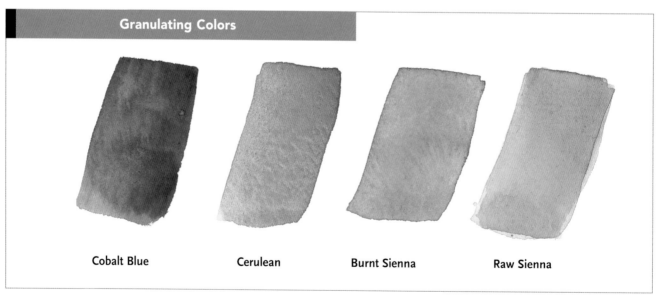

Cobalt Blue Cerulean Burnt Sienna Raw Sienna

GRANULATING COLORS

Watercolorists wishing to achieve texture on their paper prefer the granulation of some colors. The more colors are mixed together and the larger the quantity of water, the more granulation results. If you wish to minimize granulation, distilled water may help, although if you are looking for the illusion of granulation in your painting, granulating pigments are your answer. There are many to choose from depending on what effect you are attempting to achieve.

Some of the more popular granulating colors are cadmium red, cadmium red deep, rose madder genuine, cobalt violet, ultramarine violet, cobalt blue deep, ultramarine blue, cobalt blue, cerulean blue, burnt sienna, raw sienna, and raw umber.

Here are examples of the effects you can achieve by using granulating colors.

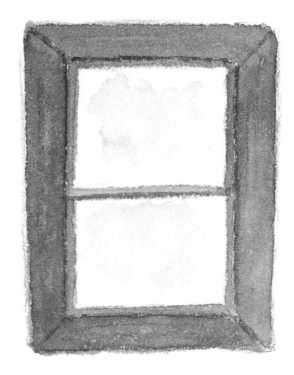

Granulating colors on a sketch of a wooden window frame.

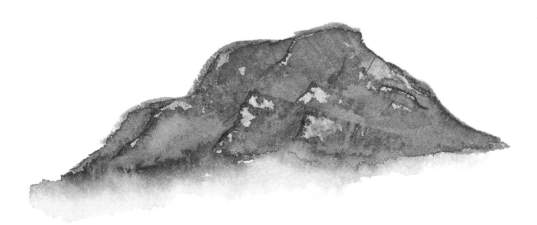

Granulating colors for creating rock colors and textures.

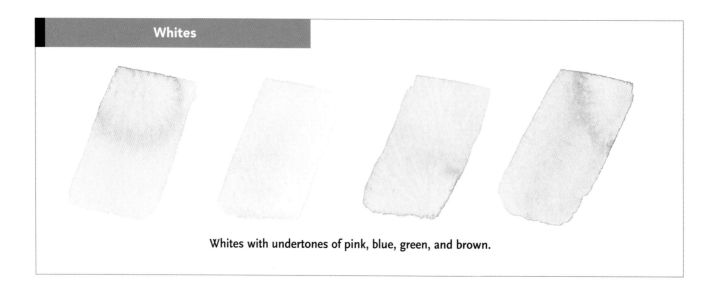

Using White As Another Option

Did you know that there are at least 100 shades of white? Interestingly, much of what we know about those shades of white was learned by past generations of artists, who worked in modest studios and yet still created a body of knowledge on which all of us can draw.

Painting with white paint does not necessarily mean that you must use white paint to achieve the light you want to convey in your watercolors. Leaving the white of the paper certainly will lead the viewer's eye to a specific area, although sometimes there are places that are not a pure white and need a tone or shade of white. In the examples, I give you a number of options so you can experiment. There are many shades of white, so you can choose what is best for you.

Winter Sky, Marcia Moses, 15 x 22 inches

Whites

Whites with undertones of pink, blue, green, and brown.

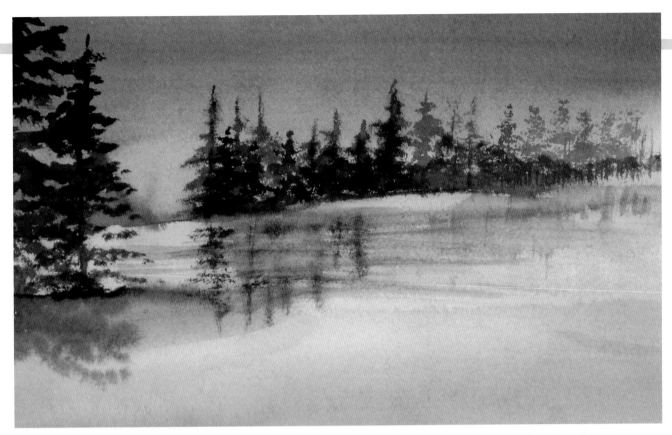

Winter Reflection, Marcia Moses, 5 x 7 inches. This painting uses split complements, orange and purple. Although not true whites, the foreground is easily read as snow and ice.

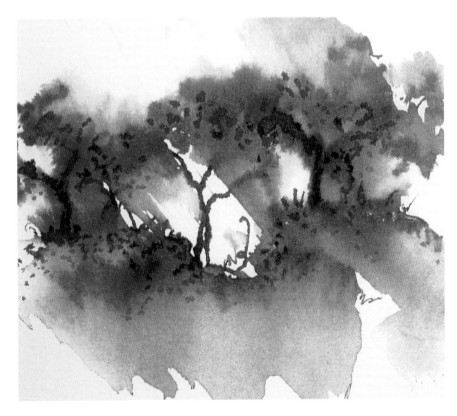

Stormy Night, Marcia Moses, 15 x 22 inches. This monochromatic painting uses the white of the paper.

Barbra's Rose, Marcia Moses, 22 x 30 inches.
The flower demonstrates the many values of white and uses of shadows.

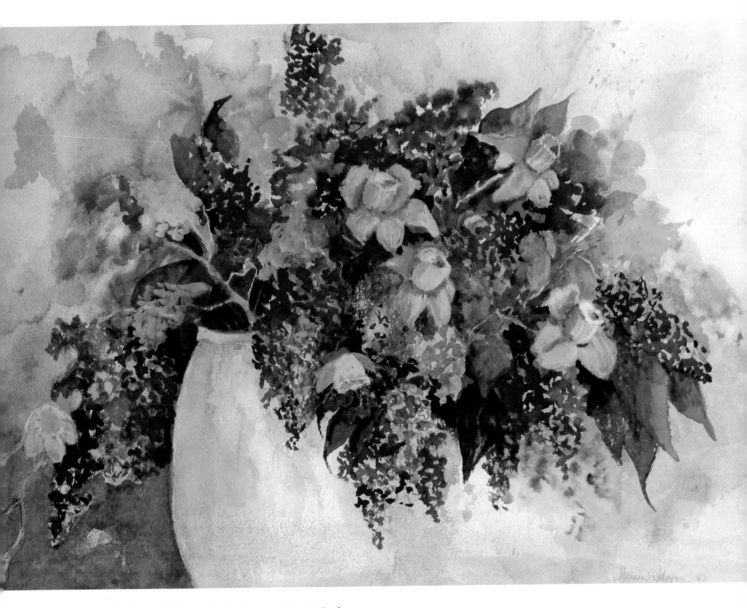

Daffodils and Lilacs, Marcia Moses, 15 x 22 inches.
The vase and background suggest some of the many whites with subtle
undertones available to a watercolorist.

Complexity, Gary Brown 11 x 14 inches

Color Techniques

Using Colors Together

IN CHAPTERS 1 AND 2, WE STUDIED MIXING, compatible combinations, values, and other aspects of color. While we can enhance a watercolor painting with a variety of techniques, all require firm understanding of color.

Knowing how to use watercolors is essential to mastering the preferred technique. When you begin a project that involves various techniques, such as mixing color, glazing color, lightening a color, or darkening a color, being aware of the desired color's properties will make your decisions less fretful and the results more predictable. You'll gain more control and be able to achieve something closer to what you had in mind.

Years of work and study will not necessarily ensure mastery of the craft of watercolor. Brushing paint on paper without planning what you want to do can bring surprises and disappointments. If you maintain an open mind, you can continue to learn about color and use that knowledge to guide your artistic efforts.

We also need to allow creativity within us to emerge and to put away all fears and not let rules inhibit us. I begin this process by telling myself, "It is only a piece of paper." When you do this, any guilt about ruining that piece of paper is gone. Remember that many more pieces of paper remain into which you can allow

your creativity to flow. Simply let yourself go and tackle all those different projects that you may have been afraid to attempt.

In fleeting moments throughout the day, as an artist, your senses take you to a place of suspended consciousness when capturing evanescent beauty. For example, when looking out your window you may see pine trees covered with ice crystals that sunlight catches just so. They sparkle brilliantly before a cloud moves, and then the effect fades. Moments like these draw you into reverie and allow your creativity to kick in. Naturally, if you're like me, you'll want to reproduce that exciting instant on paper. But memory quickly fades. If you capture what you've seen in a photo and reproduce that image on paper, you'll save that moment forever. It's good to keep a pocket or other camera handy.

In the exercises in this chapter, we will be using both our learned and instinctual knowledge about color and techniques we have already stored in heart and mind that we have worked so hard to retain. Do not be discouraged if you forget a technique; it will come back when you refer to your notes. I do encourage you to take notes and keep a journal to which you can refer. We all learn things differently and that is good. How you learn is part of your own personality.

Do not let anyone tell you your feelings are wrong. Feelings are neither right nor wrong; they just are. Put those feelings on paper, and your success will be phenomenal! Letting go of inhibitions will help free your creative self.

> **HINT FROM THE MASTERS**
>
> Edvard Munch (1863–1944) deliberately used an odd number of colors in a painting.

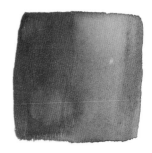

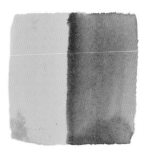

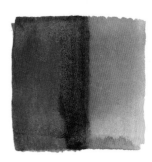

Monochromatic color schemes with complements used to darken them.

Color Schemes

There are at least five classic color schemes: monochromatic, analogous, complementary, split complementary, and triadic.

Monochromatic Color Schemes Monochromatic color schemes use one color in many values. You can add water to lighten the values. You can use a full value of the color to darken the color scheme or a drop of the complementary color to darken it further.

Analogous Color Scheme

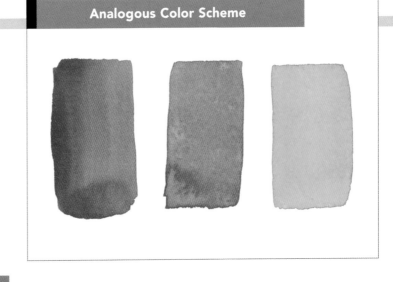

Complementary Color Complementary color schemes use two colors with different values.

Analogous Color Schemes Analogous color schemes use colors adjacent to each other on the color wheel. One color is dominant, such as red-orange or orange, while the other colors enrich the scheme, such as red, red-orange, or orange.

Complementary Color Schemes

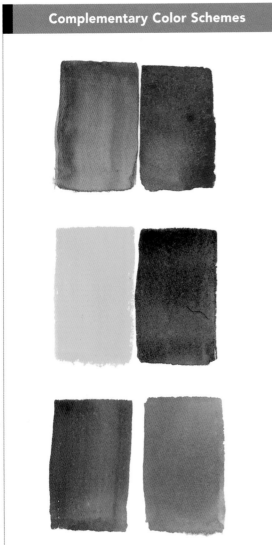

Split Complementary Color Schemes

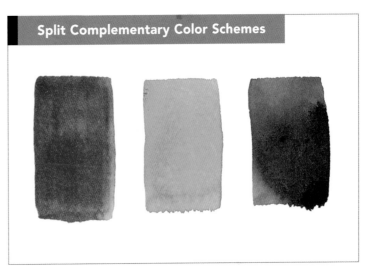

Split Complementary Color Schemes Split complementary schemes use a particular color and the two colors adjacent to its complement. This provides high contrast without the strong tension of the complementary scheme.

Triadic Color Schemes Triadic color schemes use three colors that are equally spaced around the color wheel. This scheme is popular among artists because it offers strong visual contrast while retaining balance and color richness.

Triadic Color Scheme

Monochromatic Color Schemes

A monochromatic color scheme is a one-color scheme. However, the color can be neutralized by adding its complement to lower the intensity of the color. Black and white also can be added to darken and lighten the value of the color. Water added to watercolors will also change the value of a color. It is possible to use just one color and change the value numerous times.

While the technical definition for monochromatic painting refers to using only one color, this does not mean an artist has to do so. The technique also allows for adding the complement of a color to darken or lighten

Painting of grapes and grape leaves using triadic colors

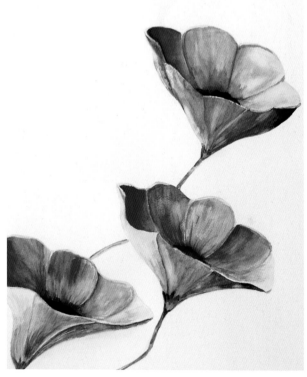

Morning Glories, Marcia Moses, 22 x 30 inches. **This painting has a monochromatic color scheme, using ultramarine.**

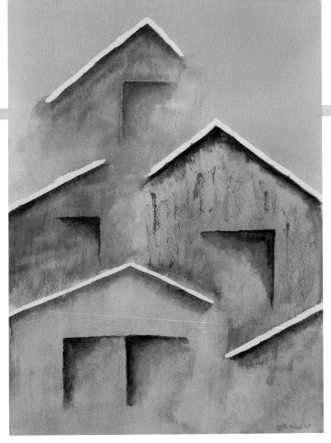

Tenement Houses II, Gary Brown, 11 x 14 inches. This monochromatic painting uses burnt sienna with the complement of ultramarine blue.

Hanging Around, Gary Brown, 11 x 14 inches. Example of monochromatic color scheme.

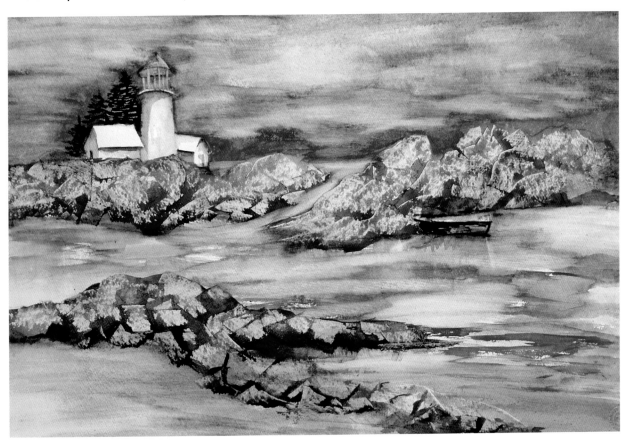

Winter Solstice, Marcia Moses, 11 x 22 inches. This monochromatic painting uses indigo with variations.

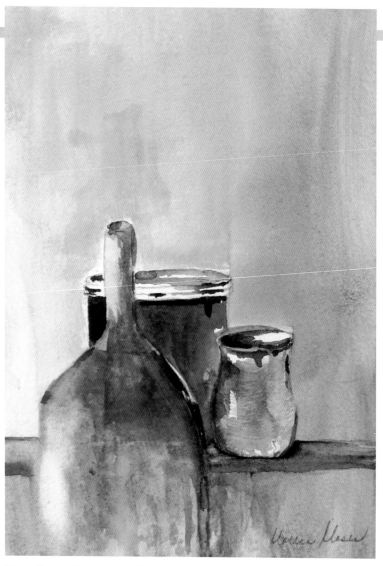

Monochromatic Jars, Marcia Moses, 5 x 7 inches

Garlic, Phyllis Amato, 11 x 14 inches

the value. This results in a painting with several different colors that achieves a monochromatic scheme.

For example, you may use burnt sienna mixed with marine blue to create an entire array of colors to produce different values of that mixture. Depending on the percentage of each color used in the mixture, the color will change. If you mix marine blue and burnt sienna in equal proportions, the mixture will be black. If you mix two-thirds marine blue and one-third burnt

sienna, the mixture will be a green. If you mix three-fourths marine blue and one-fourth burnt sienna, the result will be brown.

After you have tried these mixtures and discover that you have a beautiful brown that you want to use completely throughout your monochromatic painting, you can begin to develop different values of that color, either by adding water to lighten the value or black (equal mixture of complements, not "black" from a tube) to darken it.

Leaving the White of the Paper

Watercolor artists draw on many techniques that allow the white of the paper to achieve light effects. Also note that the natural color of the paper and whether it is rough or smooth will determine the value and radiance of the white revealed.

One option is negative painting, or painting around an object, leaving the object white and producing a white space that will stand out in the painting. Another technique is spraying paint with a spray bottle that produces either dots of paint or a mist of paint, leaving random white spaces. Yet another technique is to skim a razor blade across a dry painted surface to achieve a sparkling effect.

Other ways to produce light effects by taking advantage of the white of the paper are using masking tape or masking fluid.

One Color, Multiple Values

When as artists we look at a color, we refer to it by a name, such as cobalt blue, which is a warm blue.

Cobalt blue comes in many forms or values, however, which we can create by adding either water or the color's complement. We can take cobalt blue to an entirely different place by changing the values of the color.

If we dip a brush into water and then dip it into cobalt blue, we come up with a lighter value of the color. By the same token, if we take cobalt blue and add the complement orange, we create a darker value of the color. What we are doing is adding light with the water and subtracting light with the complement. When we add water to a color, it changes the chemicals in the color so that more light can come through. This is true of all watercolors. By adding water, the color is broken down to a lighter value. By adding a complement,

Dogwood, Marcia Moses, 7 x 11 inches. I left the white of the paper for the dogwood flower.

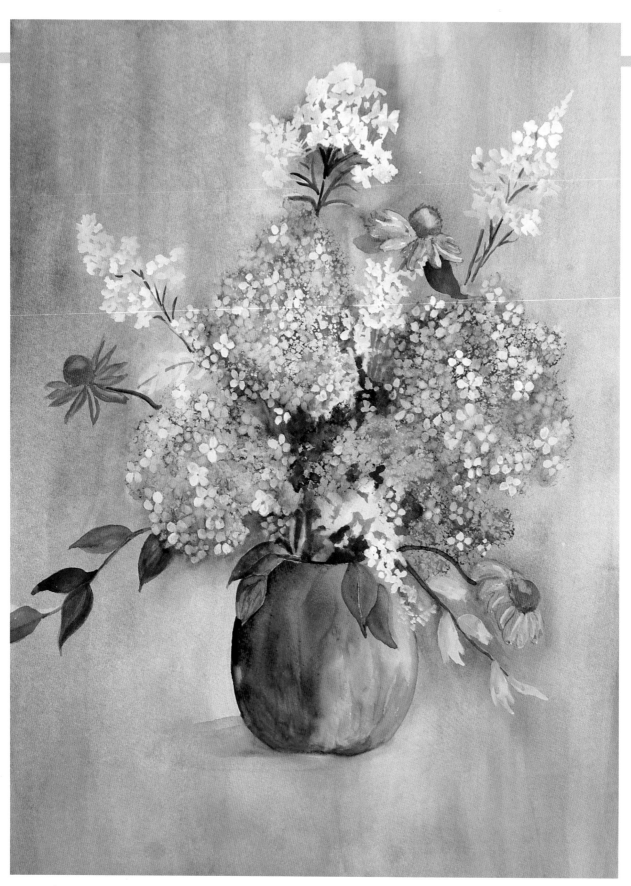

Hydrangeas, Marcia Moses, 22 x 30 inches. Multiple values of a single color.

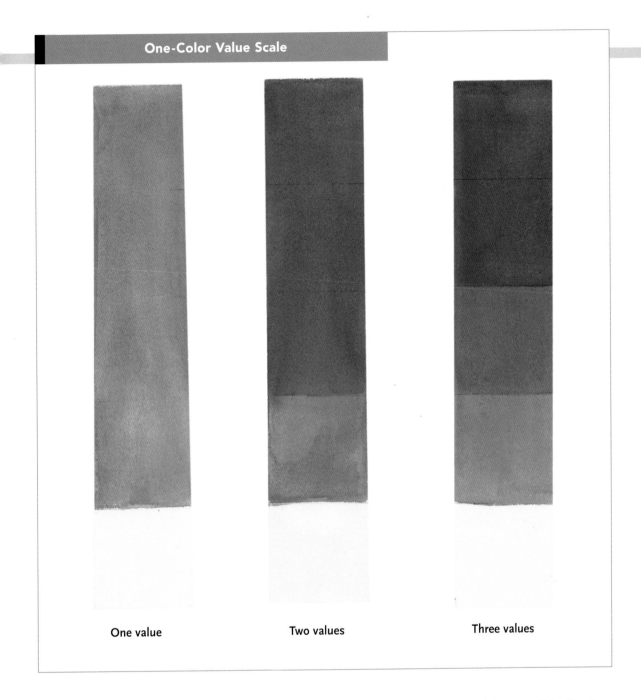

One value Two values Three values

the color of light is subtracted and eventually makes the color a gray or black.

To illustrate this, we can create a value scale such as the one shown here. Begin with cobalt blue straight out of the tube, mixed with a minimal amount of water. Paint a line of that color as shown above. Skip a space and paint another stroke down to the bottom of the line.

As you can see, the color of the rest of the line has darkened from the first block by adding the additional layer of color. If you continued doing this down the line, skipping the second box and using the same color, you would have three values of the same color. Every time you paint a color on top of itself, it becomes stronger and darker. This is the result of the decreasing amount of

light the color receives. The result is one color with many values.

You can continue painting the strip, skipping a box with each application and go on forever, and your results will be darker as you continue down the line.

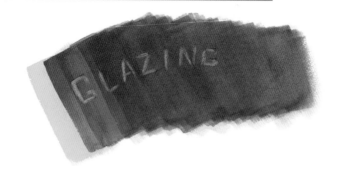

This demonstrates the color effects of glazing, using three colors in six separate glazes, rotating the colors Aureolin Yellow (AY), Rose Madder (RM), and Cobalt Blue (CB). Dry the paint between each successive glaze with a hair dryer if you want to quicken the process. Here are the glazes for a total of six: AY + RM + CB + AY + RM + CB.

Colors Used for Glazing

Aureolin Yellow **Rose Madder** **Cobalt Blue**

Glazing and Layering Color

Glazing is the technique of applying layers of paint without disturbing each layer. You can accomplish this by drying each glaze before applying another. The glazes can be the same color or different colors, and although there are situations when you will apply glazes of opaque colors, artists often want to glaze transparent colors. This allows each glaze to show through the glazes applied after it. If you apply a layer of yellow, and then apply a glaze of blue on top of it, you will be able to see the yellow glaze through the blue glaze.

Glazing differs from layering. When layering, the applications of paint are not dried between each layer. Therefore, the colors mix on the paper as each layer applied disturbs the previous layers.

EXAMPLES OF GLAZING

In the illustration on the left, the yellow shows through the colors glazed on top of it and it creates a glow.

Multiple layers of glazing will retain the same colors, although the values of those colors will be increased. This glazing process consists of nine applications of paint. With each glaze, the color becomes stronger and darker.

AN EXAMPLE OF LAYERING

When colors are layered, each color is painted on without drying between the layers. Thus, the paint is allowed to mix on the paper. That results in a blending of the colors, since the previously

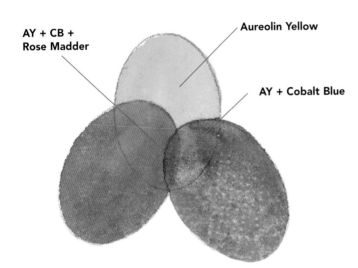

AY + CB + Rose Madder

Aureolin Yellow

AY + Cobalt Blue

Glazing with Aureolin Yellow, Cobalt Blue, and Rose Madder

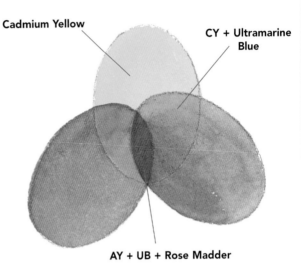

Cadmium Yellow

CY + Ultramarine Blue

AY + UB + Rose Madder

Glazing with Cadmium Yellow, Ultramarine Blue, and Rose Madder

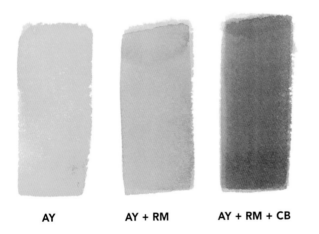

AY

AY + RM

AY + RM + CB

Glazing with Aureolin Yellow, Rose Madder, and Cobalt Blue

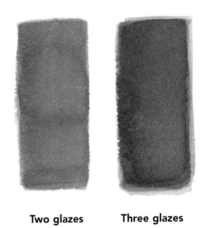

Two glazes

Three glazes

Glazing with Aureolin Yellow and Cobalt Blue

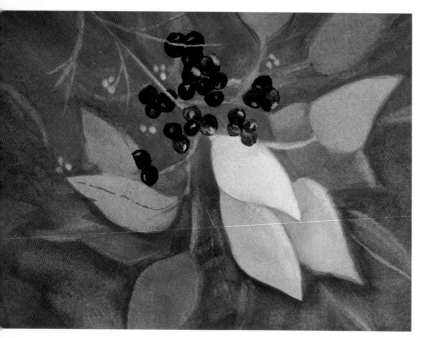

Leaves and Berries, Marcia Moses, 11 x 14 inches.
This painting demonstrates glazing with primary colors.

applied color was not allowed to set. That bottom color will not show through the colors applied on top of it as clearly. The result of layering can still be luminous, but it usually is not as luminous as a glaze.

Working with Three Colors

I really love working with three colors in what is called a triadic color scheme. There's something exciting about picking up three primaries and experimenting with them, watching them flow together to create an array of colors. Think of all the values of one color and multiply that times three. Many choices make for fun painting.

Begin the exercise by learning the properties of each color, the value range of the colors, and then experiment with their seemingly infinite possibilities.

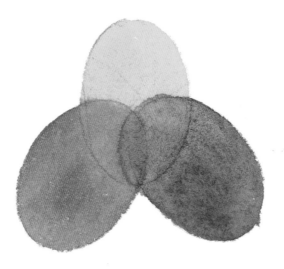

AY + RM + CB

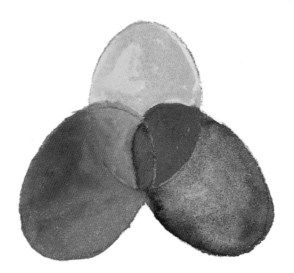

CY + UB + RM

Layering three primary colors: Aureolin Yellow (AY), Rose Madder (RM), and Cobalt Blue (CB); and Cadmium Yellow (CY), Ultramarine Blue (UB), and Rose Madder (RM).

To darken the value of a specific primary, for example, simply mix the two primaries that you have not used in that area of the painting. Add a small dab of that mixture to the original primary. What you have done is add the complement to create a darker value.

For example, if I have a red apple that has been painted with the colors red and yellow, applied on top of each other, these two colors will mix together to make orange in some parts of the apple. To darken the orange, I would use the complement blue. If I just needed to darken the red, I would mix the other two primaries—blue and yellow—to create green, which is the complement of red.

Working with Complements

Remember that complements are those colors located across from each other on the color wheel. Red and green are complements, as are blue and orange, and yellow and violet.

Painting with complements can be fun, but it also can be educational. Discovering all the hues that two colors can produce when combined can give you a great lesson in values.

When we use complements to create visual harmony, we are allowing the viewer's eye to move with ease through the painting guided by the use of the push-pull method (placing dark values next to light values). If you take, for

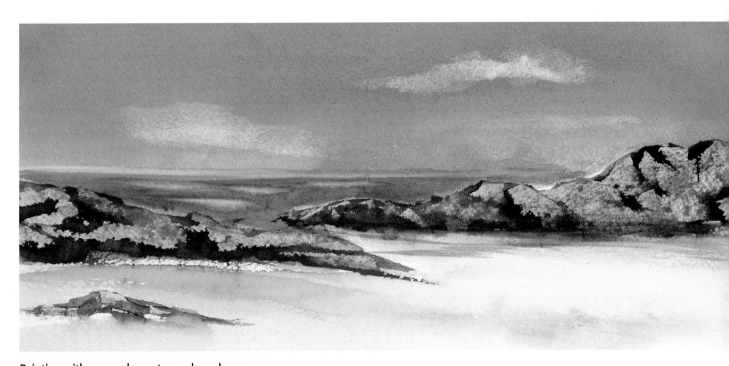

Painting with a complementary color scheme.

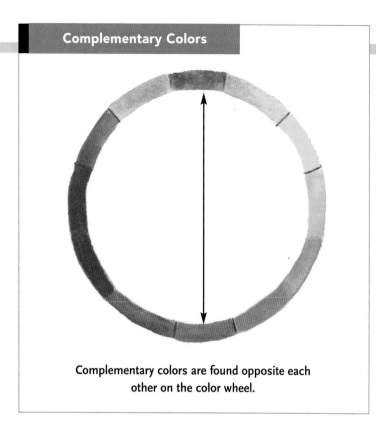

Complementary colors are found opposite each other on the color wheel.

example, a folded cloth arranged as a drape, the creases will not be visible or three-dimensional if you use the same value. In order for those creases to show and the cloth not to appear flat, we use the push-pull method to create the feeling of movement and dimension, thus making the cloth appear so real that you feel you could remove it from the paper.

In the following demonstrations, you will see this clearly.

Working with Tertiary Colors

Tertiary colors, which sometimes are called intermediate colors, result from mixing a secondary and a primary color. Some examples of intermediate, or tertiary, colors are red-orange, red-violet, yellow-green, yellow-orange, blue-green, and blue-violet. They are all made by mixing a primary color with an adjacent secondary color.

On the color wheel, the tertiary colors are located between the primary and secondary colors from which they are made.

Tertiary Colors

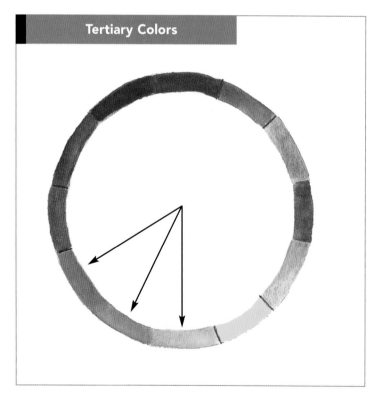

Working with Split Complements

A split complement is the combination of a hue and the two colors on both sides of its complement.

Color schemes using split complements can be fun and exciting. This basic color mixing exercise is designed to help you learn to successfully mix complementary and analogous colors into split complements to create smooth transitions of value.

As you look at the color wheel below right, you can see the many combinations available for split complements. Begin with a primary color and add the two colors on each side of its complement. Red, yellow-green, and blue-green become a split complementary color scheme. The two other colors in the color scheme, if you begin with blue, would be red-orange and yellow-orange. If you begin with yellow, the split complements would be red-violet and blue-violet.

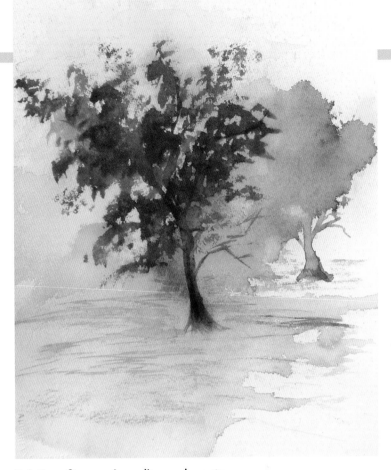

Painting of trees using split complements.

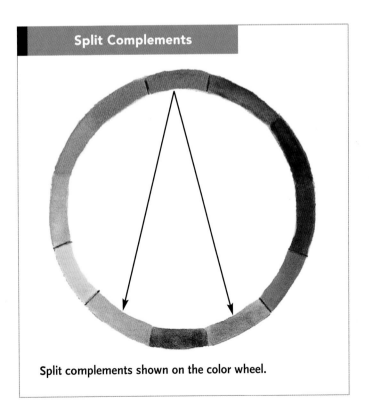

Split Complements

Split complements shown on the color wheel.

Zinnias, Marcia Moses, 5 x 7 inches. Example of split complement color scheme.

above Floral, Shella Marzich, 11 x 14 inches. Example of a vignette with complementary color scheme.

right Beachcomber, William Moses, 14 x 22 inches. This painting uses split complements.

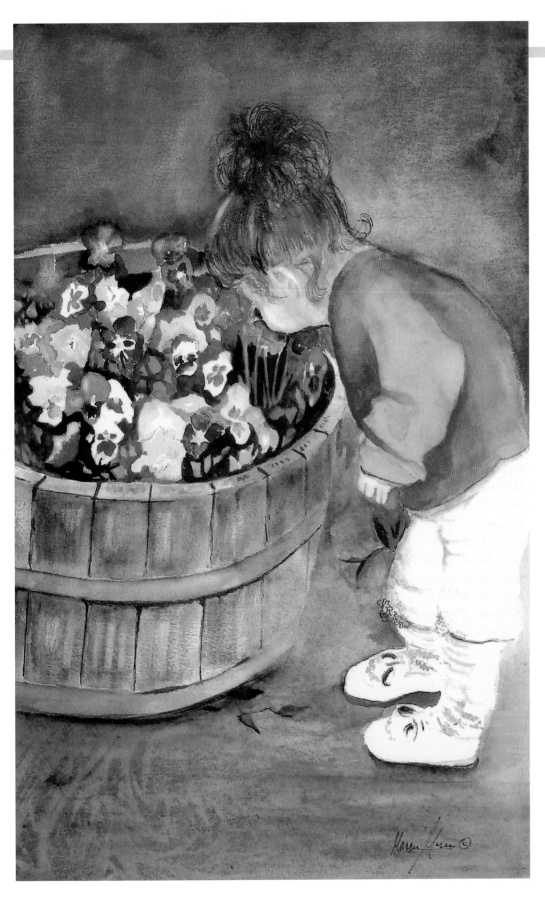

Nicole Smelling the Flowers, Marcia Moses, 15 x 22 inches. This painting uses a rainbow of colors.

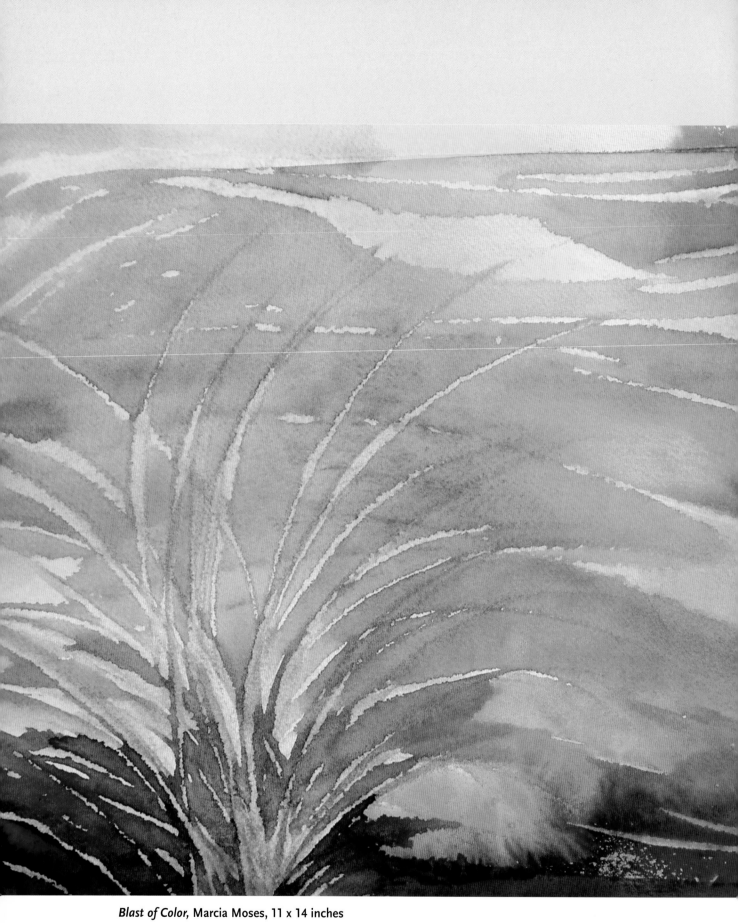

Blast of Color, Marcia Moses, 11 x 14 inches

Color Applications

Thinking in Color

ARTISTS ALWAYS HAVE SOMETHING NEW TO LEARN; thinking in color is no exception. Perhaps you were riding in a car or even driving home and seeing what you do every day, observing the beauty of your surroundings, when suddenly the inspiration for your next painting pops into your head and the exciting moment gets your creative juices flowing. I have learned to stop blurting out my excitement because sensitive drivers become scared to death, thinking something is wrong. (Was that an armadillo crossing the road?)

Close your eyes and remember how things appeared at enlightened moments or places—when you fell in love, held a child in your arms, smelled the first summer rose, watched an old couple still in love, sniffed salty ocean breeze, or opened the door of your dream cottage in the wild.

Now imagine all these things in color. How would you paint those impressions, sensations, and feelings? How do you see that tree you sat under for your first kiss? Was the tree green? Probably not. It probably was oranges, reds, and all kinds of warm colors. If you have ever had someone very close to you die, you would most likely think of that memory in shades of blue. We tend to

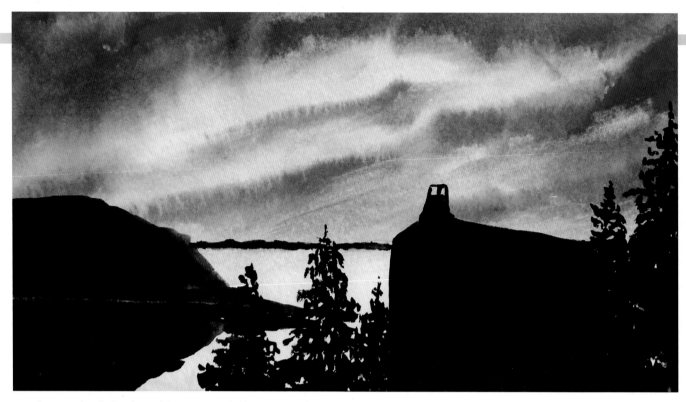

Monhegan Island, Carol Pershing, 11 x 14 inches

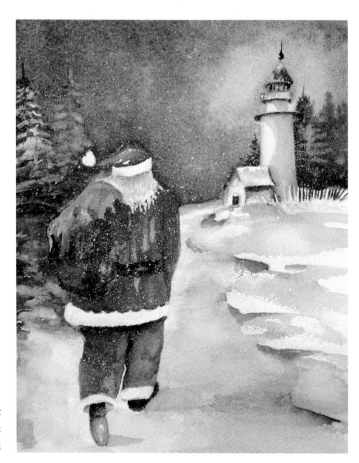

Santa's Visit
Marcia Moses
11 x 14 inches

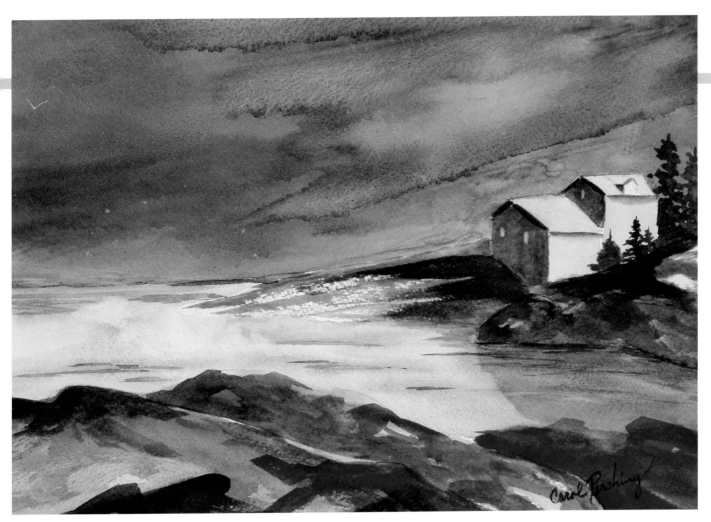

Monhegan Sunset, Carol Pershing, 11 x 14 inches

associate love with the color red and blue with sadness. Of course, blue may also color sky or ocean and suggest the clean and vast, and maybe that little cottage has a yellow glow coming from the window that gives us a warm feeling.

When I have painter's block (similar to writer's block), I close my eyes and let my feelings take over. Sometimes I imagine that I am walking in a field of flowers and suddenly note the smell of a gardenia. After I sense this, I am ready to paint the flower and want it to smell like gardenias. Of course, that's only possible if I spray the painting with gardenia cologne. I've never done that, although it would certainly create the mood. This may seem crazy, but the technique works for me.

Color and Line Direction

We can describe the physical characteristics of line and color and the way those characteristics control the design of a painting. A few words for the way paintings are designed include *horizontal, vertical, angular, zigzag, spiral, broken, curving,* and *diagonal.* Color can make these lines even more dramatic and evocative.

First, look at a painting that you like, and then circle all the words above that describe the lines and the color that you see. Are there other lines or colors that you see that are not included in this list? Next, locate the expressive qualities of the lines and color.

Here are some ways to describe the expressive quality of a variety of lines.

Vertical lines tend to create a sense of strength and balance in a composition.

Thick lines can make the work of art appear aggressive and strong.

Thin lines sometimes can be read as delicate and fragile.

Curving lines may create the appearance of harmony, rhythm, and gracefulness.

Zigzag and **diagonal lines** can be read as energetic, explosive, and dramatic.

The color of the lines can intensify the viewer's feelings that the artwork evokes.

What expressive characteristics do you find in these paintings? Note the color of the lines. Does the color of the lines create movement or direction, or does it evoke certain feelings?

Because line and color are important visual elements of a composition, you need to explore the lines in the painting to understand how color affects them.

DIAGONAL VERSUS VERTICAL AND HORIZONTAL LINES

The diagonal line's intensity is without equal. It suggests depth or movement. The eye's peripheral vision is sensitive to movement or to any diagonal, so it calls for the viewer's complete attention. That's why traffic signs designed to warn about hazards are diamond-shaped, using diagonals.

Vertical and horizontal lines suggest a static or decorative condition. Consider the top hat: it appears taller than it is broad, but this is an illusion.

Onions, Marcia Moses, 11 x 14 inches

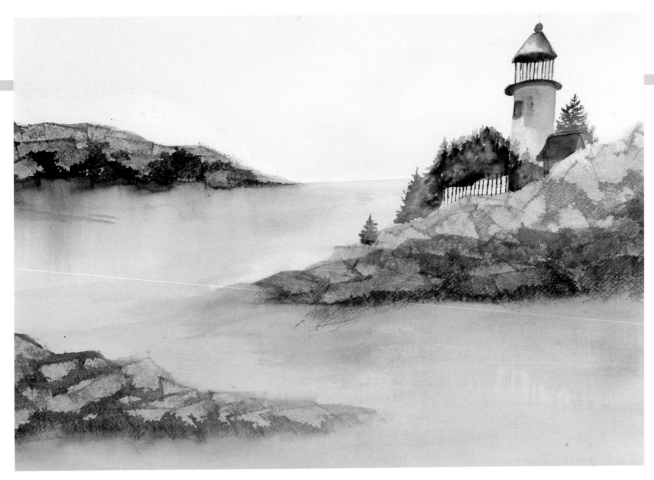

Tranquility, Marcia Moses, 15 x 22 inches

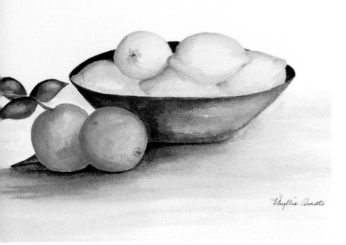

Lemons and Oranges, Phyllis Amato, 11 x 14 inches

White Birch, Giovanna Nicandro, 11 x 14 inches

Complexity, Gary Brown, 11 x 14 inches. Note the use of diagonal lines.

HINT FROM THE MASTERS

Edgar Degas (1834–1917), when a composition with dancers wasn't quite working, painted a new leg kicking into the painting, thereby adding more diagonal lines, color, and fresh interest.

Many modern artists have experimented with the effects of line direction. Among the most important is the Dutch painter Piet Mondrian (1872–1944). By showing how to eliminate the diagonal line, he led the way to a new concept of art. He said, "Any object can be interpreted in terms of horizontals and verticals." To relieve the monotony of using only verticals and horizontals, he added small areas of primary colors to his pictures.

Vertical and horizontal elements (lines and shapes) produce a feeling of calm and order. Diagonals, on the other hand, are more dynamic and suggestive of movement.

Putting horizontal lines in the bottom of a picture, vertical lines in the middle, and diagonal lines at the top increases the decorative quality of line by its multiple, repeated use.

Little Mermaid
Mary Nieto
11 x 14 inches

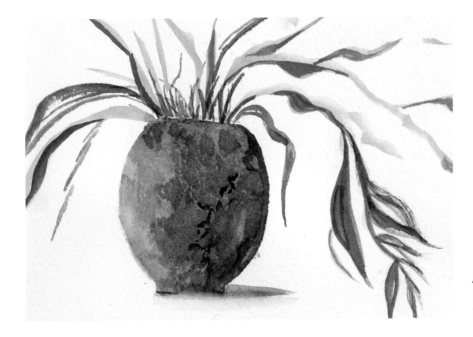

A Little Texture
Marcia Moses
11 x 14 inches

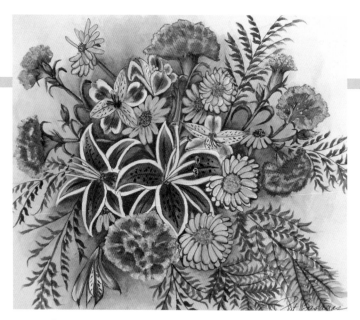

Remembrance, Pat Bagueros, 11 x 14 inches

HINT FROM THE MASTERS

Georgia O'Keeffe (1887–1986) completely filled the page with a single colorful flower, painting the petals and insides close up. The background and foreground seem one in her honeybee's eye-view of the flower.

Color in Floral Paintings

When I think of florals, I remember spring and summer, working in my garden, and the beauty of new love blossoming with romance. I imagine either bold and bright colors or soft pastels, because flowers come in all the colors of nature.

To preserve favorite memorieson paper is one of the nicest things about painting flowers. Draw on your imagination and artistic license to create colorful floral paintings.

The watercolors here are examples that illustrate color techniques for painting flowers. When rendering flowers on paper, I can nearly smell them and visualize that one perfect rose or lilac that makes my heart sing. Not only do I paint flowers plucked from my garden, but I also draw inspiration from those discovered in favorite photos, found in my dreams, and recalled from memories of summers past.

Daffodils and Lilacs
Marcia Moses
15 x 22 inches

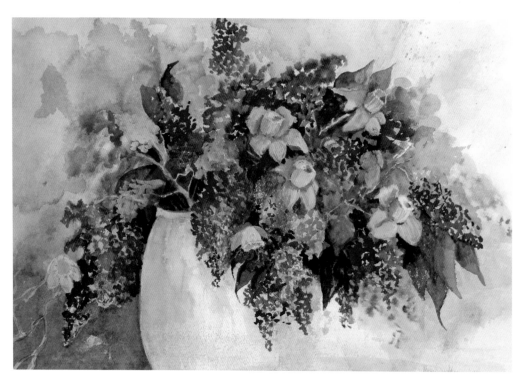

Potted Plant, Marcia Moses, 11 x 14 inches

Beauty Berry Bush, Marcia Moses, 11 x 14 inches

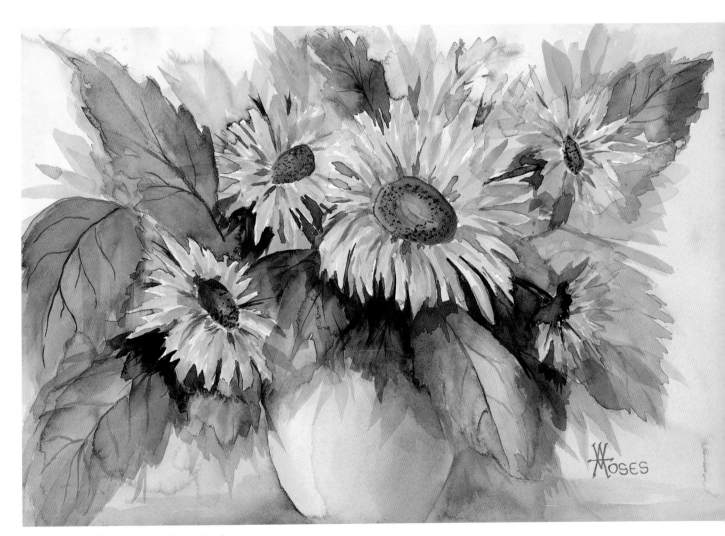

Sunflowers, William Moses, 11 x 14 inches

Calla Lilies, Kris Wyler, 11 x 14 inches

Vase of Flowers, Shella Marzich, 11 x 14 inches

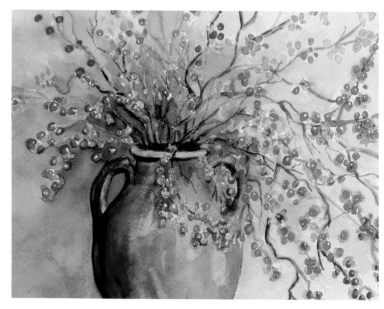

Bittersweet, Marcia Moses, 11 x 14 inches

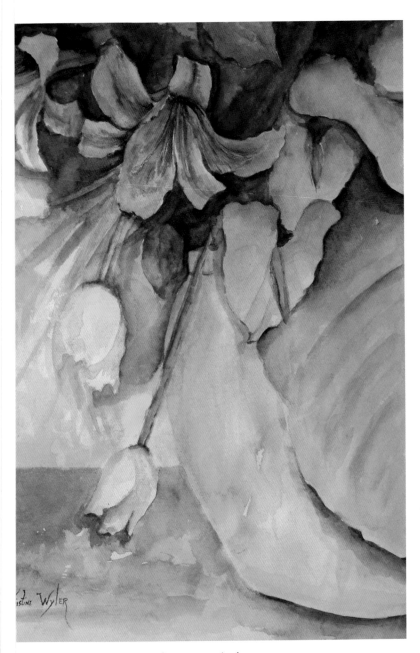

Fallen Tulips, Kris Wyler, 11 x 14 inches

Lupine, Carol Pershing, 11 x 14 inches

Mackenzie, Shella Marzich, 11 x 14 inches

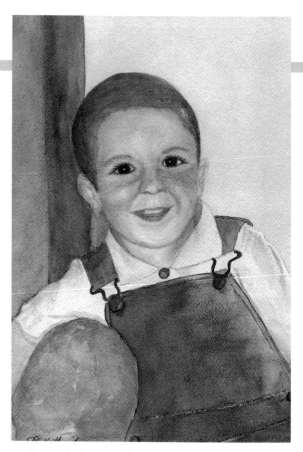

Zachary, Shella Marzich, 22 x 24 inches

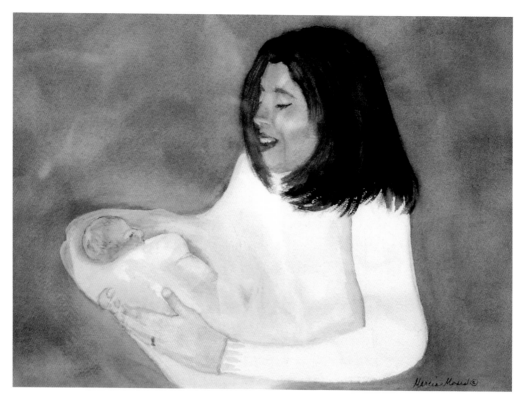

Dina and Baby, Marcia Moses, 16 x 20 inches

Skin tone samples mixing three colors.

AY + RM + CB

RM + CY + UB

BS + RM + CB

BS + CY + UB

UB + CY + CB

Color in Shadows

Not all shadows are equal. Two very different kinds of shadows occur in any subject: *cast shadows* and *form shadows*. Identifying these and approaching them differently, rather than just painting a generic shadow, will enhance any painting.

So what's the difference between a cast shadow and a form shadow?

CAST SHADOW

A cast shadow is what we generally think of as a shadow. It's a shadow created by something blocking the light source. For example, a cast shadow is the shadow of a tree, created by the sunlight that falls on the ground, or the shadow on a tabletop from an apple sitting on it.

A cast shadow is the darker type of shadow; it is a result of the light source being blocked. It has a sharp or more definite edge to it. It is important to remember that a cast shadow is not a solid thing that is the same tone throughout. The farther a cast shadow is from the object that is creating it, the lighter it gets and the softer or less defined its edge becomes.

FORM SHADOWS

Form shadows are shadows on the side of a subject that is not directly facing the light source. They have softer or less defined edges than cast shadows. Form shadows are lighter than cast shadows because they are not created directly by a blocked light source. Form shadows are subtle shadows, essential for making a subject appear

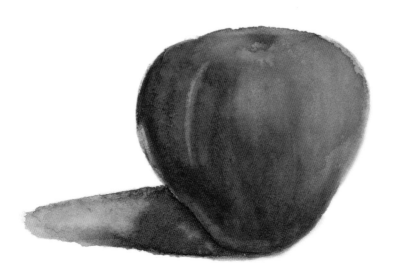

Cast shadow of an apple

three-dimensional rather than flat. They create volume and aid in modeling the desired form. The changes in form shadows require very careful observation. Squinting your eyes at the subject often will help you see them more clearly. If most of the subject is in direct light, there will be very few form shadows visible on it.

Consider, for example, a vase on a table where the light source from the sun is at about 2 o'clock in the afternoon. The top edge of the vase is in the direct light, and there will be a cast shadow made by the vase on the table. The parts of the vase not in direct light are in the form shadow.

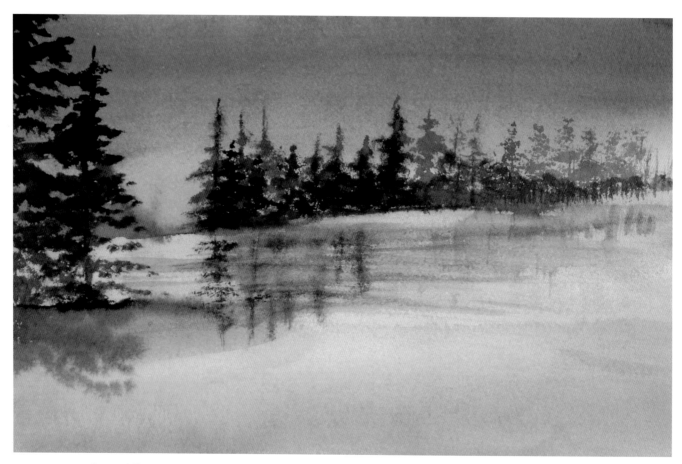

Winter Reflection, Marcia Moses, 5 x 7 inches

THE COLOR OF SHADOWS

The color of a shadow depends on the color of the object being shadowed. For example, if the object is a multicolored vase and the light is at 3 o'clock in the afternoon, the opposite side of the vase will have a long shadow and will reflect the colors in that multicolored vase.

Light Source Also consider the location of the light source relative to the object.

If the light source is from the sun at noon, or directly *overhead,* there will be a shorter shadow just below the base of the bike seat and under the tire. If flowers are in the vase, there will be shadows underneath the flowers hiding the light from the object the vase is sitting on. The colors would be a darker value of the flower that hides the light.

If the subject is *backlit,* the shadows will be in front of the object, and they will be cast shadows.

For example, consider a lighthouse perched on a hill and backlit by the sun at 10 o'clock in the morning. The lighthouse is lighter in color where the sun hits it, as is the grass in front of the subject.

The shadow would be passing over the grass, thereby making it darker in color than the rest of the grass. The cast shadow can be created by using a glaze of the complement red on top of the green grass.

After you begin painting and closely looking at colors, you'll soon realize that simply reaching for a tube of black paint whenever you need to add a shadow does not work. The result is not subtle

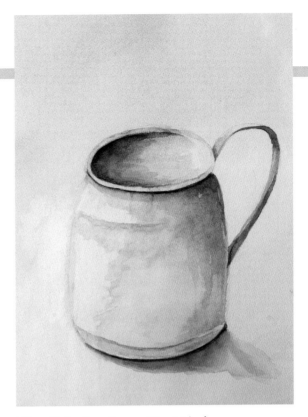

Silver Stein, **Gary Brown, 11 x 14 inches**

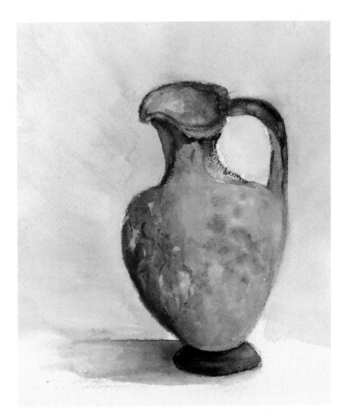

Vessel, **Marcia Moses, 5 x 7 inches. Various colors of shadows creating form**

enough to capture a realistic shadow. The French Impressionist painter Pierre-Auguste Renoir (1841–1919) said: "No shadow is black. It always has a color. Nature knows only colors. … White and black are not *colors*." So if they eliminated black from their palettes, what did the Impressionists use for shadows?

The True Colors of Shadows For the French Impressionists, working from the relatively new theory of complementary colors, the logical color to use for shadows was violet, being the complement of yellow, which was the color of sunlight. "Color owes its brightness to force of contrast rather than to its inherent qualities," Claude Monet (1840–1926) said. "Primary colors look brightest when they are brought into contrast with their complementaries." The Impressionists created violet by glazing cobalt blue or ultramarine with red, or by using new cobalt and manganese violet pigments that had become available to artists.

Hills of Rome, Marcia Moses, 15 x 22 inches

Hills of Rome with shadows, Marcia Moses, 15 x 22 inches

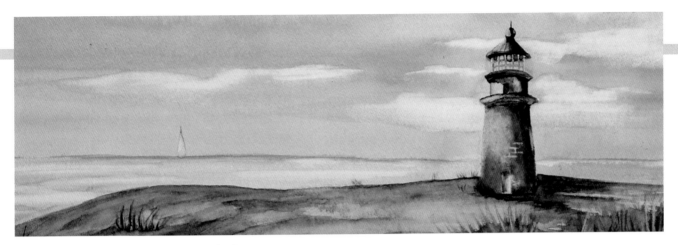

Gay Head Light, Marcia Moses, 8 x 22 inches

Monet painted his moody interiors of Saint-Lazare station, where the steam trains and glass roof created dramatic highlights and shadows, without earth pigments. He created his astoundingly rich array of browns and grays by combining new synthetic oil-paint colors (colors we today take for granted) such as cobalt blue, cerulean blue, synthetic ultramarine, emerald green, viridian, chrome yellow, vermilion, and crimson lake. He also used touches of lead white and a little ivory black. No shadow was considered as being without color, and the deepest shadows were tinged with green and purple.

Ogden Nicholas Rood's book *Modern Chromatics* (1879) offered a scientific understanding of color theory that had an impact on the paintings of the Impressionists. Rood, however, reportedly detested their paintings. He said, "If that is all I have done for art, I wish I had never written that book!"

Trying to Observe Color "I'm chasing the merest sliver of color," said Monet, describing his attempts to observe and capture the colors in nature. "It is my own fault; I want to grasp the intangible. It is terrible how the light runs out,

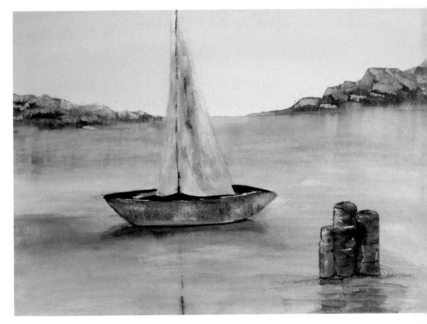

At Dusk, Marcia Moses, 22 x 30 inches

taking color with it. Color, any color, lasts a second, sometimes three or four minutes at a time. What to do, what to paint in three or four minutes? They are gone, you have to stop. Ah, how I suffer, how painting makes me suffer! It tortures me."

According to Monet's theories, impressionistic painting relied not only on the way a painter's eyes saw an object, but also on the way his mind perceived it.

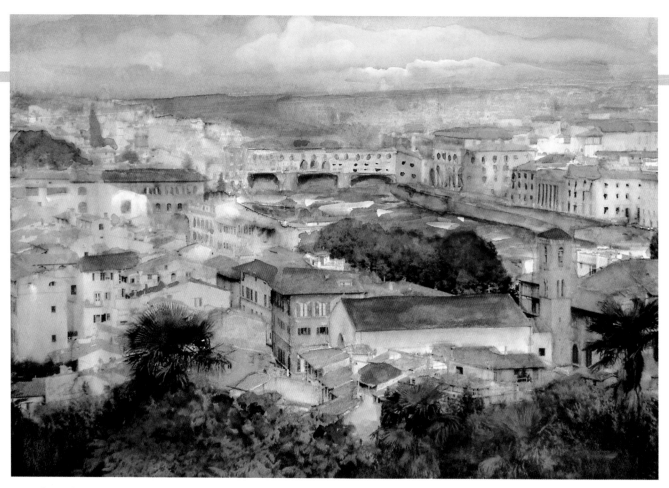

View from the Piazza Michelangelo of Florence, Marcia Moses, 22 x 30 inches

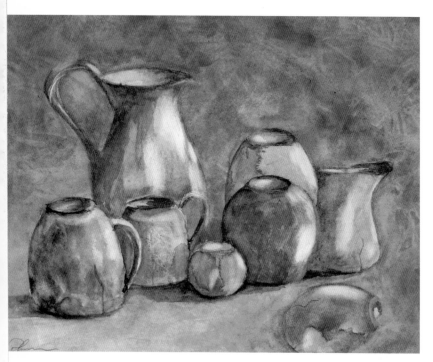

Old Vessels, Bill Johnson, 11 x 14 inches

Eventually you'll find your own style. Sometimes it takes a while, but all the knowledge you acquire along the way will only add to your ability to paint the way you want.

Now that you know how to mix color and recognize the properties of color, you can develop a painting, using your imagination to determine your subject. For example, if you have decided that you want to do an abstract painting, you already have the knowledge of how complements enhance each other. You begin by laying out your design and then adding the colors that will lead the eye through the painting in a pleasing effect. If you are happy with your color choices and the visual effects, then you have created a painting that your viewer will also appreciate.

San Gimigano Winery (Italy), Marcia Moses, 13 x 19 inches

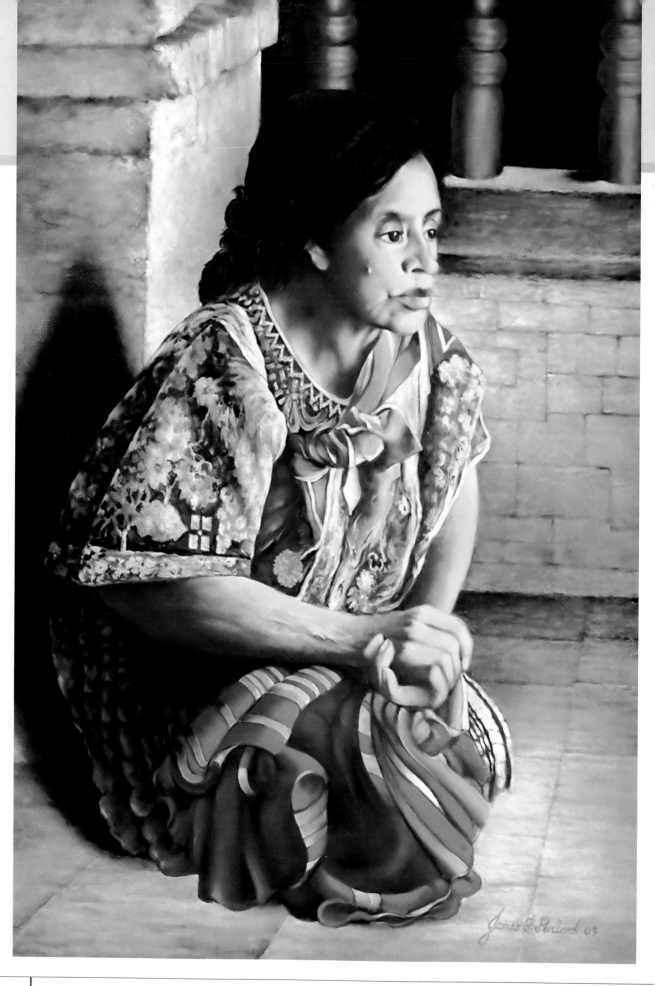

Mastering Color

above **The David,** photo of replica of bust
by Michelangelo

left **Pueblo Woman,** James Penland,
acrylics, 30 x 40 inches

Color Theorists

SIR ISAAC NEWTON (1642–1727) FIRST SPLIT white
sunlight, using a prism, into the red, orange, yellow, green,
cyan, and blue beams. (We give them more specific names
today.) He then joined the two ends of the color spectrum
together to show the natural progression of colors in
his theory of the color wheel, which resembles what we
know today.

In the next century, Johann Wolfgang von Goethe
(1749–1832) began studying the psychological effects of
colors. He noticed, for example, that blue gives a feeling of
coolness and yellow has a warming effect. Goethe created a
color wheel that illustrated the psychological effect of each
color. He divided all the colors into two groups: the plus side
(from red through orange to yellow) and the minus side
(from green through blue to violet). Colors on the plus side
produce excitement and cheerfulness. Colors on the minus
side are associated with weakness and unsettled feelings.

What Makes a Master Artist?

Many artists, living and deceased, have used color brilliantly.

One of my favorites is Andrew Wyeth (b. 1917). With his wonderfully executed works, Wyeth has captured my heart and inspired my soul. His works stimulate the senses and draw out feelings I'd forgotten that I had, making me grateful that he was born. Seeing his work in the Helga collection of paintings (a series that Wyeth kept secret until it was finished) of Prussian-born neighbor Helga Testorf, who became his model, was one of the highlights of my artistic life.

"With watercolor, you can pick up the atmosphere, the temperature, the sound of snow shifting through the trees or over the ice of a small pond or against a windowpane. Watercolor perfectly expresses the free side of my nature," Wyeth said.

In Italy, artworks like Michelangelo's *David* and the Sistine Chapel ceiling in the Vatican brought me to tears. The *Pietà* is so awe-inspiring that it made me wonder how anyone could have had the vision to release such beauty from a block of marble. There is no experience like seeing the real thing—the actual paintings or sculptures by Sandro Botticelli (1445–1510), Leonardo da Vinci (1452–1519), and Michelangelo (1475–1564)—

> **HINT FROM THE MASTERS**
>
> Andrew Wyeth (b. 1917) saw himself as an abstract painter. Reconsider these effects in his otherwise realistic paintings.

rather than viewing their works in the pages of art books. Make viewing works of art up close a goal for yourself.

STUDYING THE OLD MASTERS

We continue to draw on the Old Masters, European artists working between 1500 and 1800, for inspiration today. They inspired the recognition and admiration of their peers in their own time, just as they do today.

Being a technical master of a given art (trade guilds also had rigorous standards) was necessary, but so too was exploiting such techniques and allowing them to take shape in the imagination to assume individual expression. When asked how he created a famous sculpture, Michelangelo responded: "I saw the angel in the marble and carved until I set him free."

The Renaissance Italian genius was, primarily, an artisan who had learned the craft of sculpture from his elders. However, that fails to explain how he "saw" a nonexistent celestial figure in a piece of marble with such clarity that he could create its image in three dimensions.

The concept of imagination remains one of the greatest mysteries of psychology. Granted, we cannot all paint the ceiling of the Sistine Chapel, but almost all of us have an ability to come up with ideas or images. It is time that artists paid more attention to the power of imagination.

Imagination means different things to different people, just as art is in the eye of the beholder.

Contemporary Artists

As an artist, I continue to study other artists' works and learn from them so that I will never stop growing. In this chapter, I have chosen a number of artists who were either my teachers or whom I've admired for their art and integrity. Some were close friends who have passed away, and others continue painting wonderful works of art. I'm grateful to these mentors and dedicate this chapter to artists who have inspired me with their vision. In my eyes, they are quintessential masters of color.

Roman Monk, Helen Van Wyk, oil, 6 x 8 inches

HELEN VAN WYK

Helen Van Wyk (1930–1994) enjoyed a brilliant career as a painter, teacher, and television host of the 1990s *Welcome to My Studio* series on PBS. She began painting at age 12. She has created portraits of people from all walks of life, the theater, business and industry, and from rural, urban, and marine settings.

Her exquisite landscapes and still lifes are featured in galleries and museums in over 300 cities. Admired for her techniques, Helen was a popular teacher in great demand.

In the late 1960s, I met this wonderful woman, who could always make me laugh, and I was in awe just watching her paint. Helen taught me early in my career, when I was painting in oils. Unfortunately, in about 1986, I became allergic to the oils and paint fumes, so I turned to watercolor, my current medium. Oh, what I would give to talk to her now and to tell her how much her color recipes have helped me in watercolor! I remember her fondly.

I like to think that Helen is an angel, sitting on my shoulder, guiding my hand with deft strokes of the paintbrush. (I like to suppose that my mother sits on the other shoulder.) I was delighted to see Helen again in 1993 in Cape Ann, Massachusetts, a year before she passed away. Enjoy the amazing paintings on these pages that demonstrate her remarkable mastery of color.

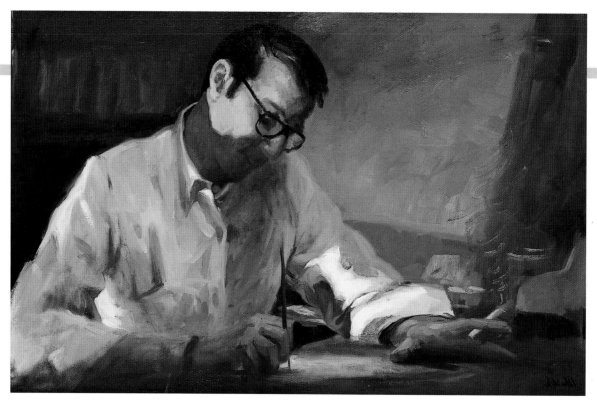

The Cartoonist, Helen Van Wyk, oil, 22 x 20 inches

Still Life, Helen Van Wyk, oil, 22 x 30 inches

left Helen Van Wyk's
studio in Rockport

Tuscan Steps, Helen Van Wyk, oil, 16 x 20 inches

right page
Dance Break, William Lawrence, watercolor, 36 x 48 inches

Josh Hankey, William Lawrence, watercolor, 48 x 60 inches

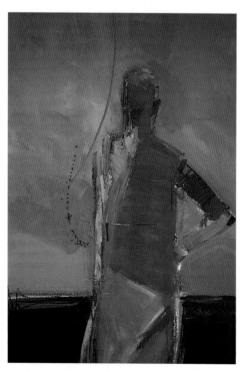

Reluctant Search, William Lawrence, watercolor, 36 x 48 inches

WILLIAM "SKIP" LAWRENCE

The first word that comes to mind when thinking of **William "Skip" Lawrence (b. 1943)** and his art is *fun*. He thoroughly enjoys his craft and makes sure, through his teaching style, that you do, too. The warmth and passion he brings to teaching transfers to his students, resulting in an environment where every class propels you to another level. In my opinion, Skip is perhaps one of the best colorists of our time.

In his words: "It is only when I look beyond the bark, trunk, and leaves of a tree and stare deeply into the woods that the essence of a forest is made rich and clear. My work is not impressionistic. I do not look for cursory impressions but gaze intensely for the soul of the subject. Enriched color delivers the emotional content of my works, whether landscape, interior, or figure. Most of my paintings are not of specific places but are universal expressions of things both seen and imagined that I hope will strike a chord in anyone who sees them."

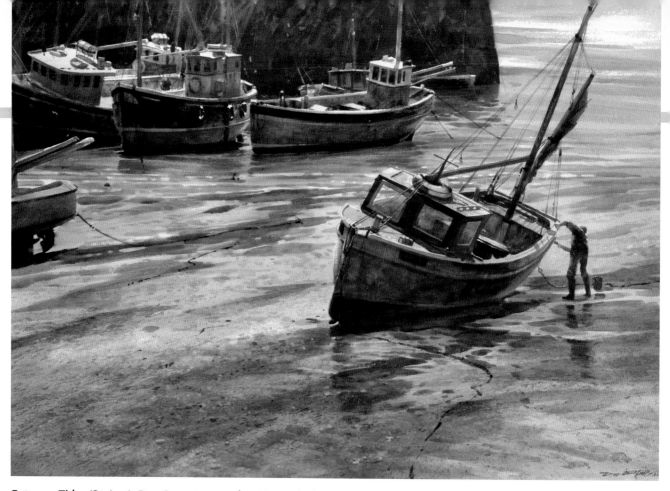

Between Tides (St. Ives), **Don Stone, watercolor, 20 x 29 inches.**
Courtesy of the Canton Museum of Art, donated by Don Stone in memory of Leander Zwick.

DONALD STONE

Although **Donald Stone (b. 1929)** was an unwitting educator, he taught me a great deal about color and the use of it in watercolor. The classroom was the stony shores of Monhegan Island, Maine, where I would sit and simply watch Don paint. His vibrant subjects and dramatic seascapes enthralled me and inspired me to investigate more fully the use of color in my art.

It's an arresting experience to view Don Stone's artistic accomplishments. Few artists have so successfully mastered so many different paint media, and, with each new exploration, presented a fresh means of expression. Working with vigorous, moving watercolor, he captures momentary visual sensations and an immediacy that's translated into works of stunning accuracy and vitality in the precision of his oils and watercolors.

The painterly quality of his oils reinforces the "consistency in variety" in all his painted responses, and, like his other paintings, they are conspicuous for their sheer visual pleasure. Another uniting factor in these versatile paintings is the distinctly American point of view. Don Stone's deeply rooted respect for the American tradition of realism is expressed in his choice of subject, from his well-known marine paintings to the rural New England landscapes, both occasionally peopled with characters that embody the very pulse of America and its heritage.

His works have appeared in numerous university and museum collections and in books and magazines.

ROBERT C. BENHAM

Robert C. Benham (1908–2002), a native of Gloucester, Massachusetts, was noted for his New England landscapes, seascapes, and marine paintings that capture nature's many moods. A warm, compassionate man, Bob was always willing to share the process and techniques that define his paintings. His dramatic seascapes toss viewers into an ocean of color and realism unmatched by those of many peers.

Bob's love for the sea, evident in his canvases, comes as a result of growing up in a sailing family. His works are displayed in many private and public collections. He has won numerous awards and has had several one-man shows. He has exhibited throughout the country, notably in the National Academy of Design and the Salmagundi Club in New York City.

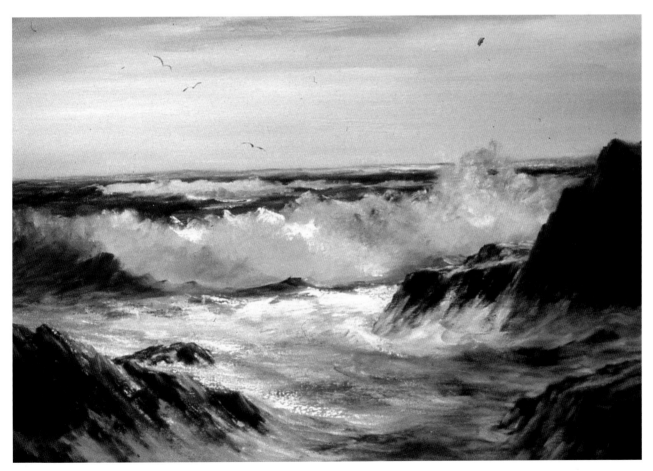

Surf at Bass Rocks, Robert C. Benham, oil, 42 x 52 inches

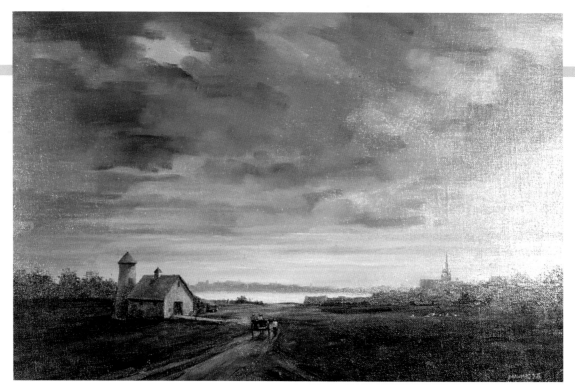

Farm Scene, Robert C. Benham, oil, 24 x 36 inches

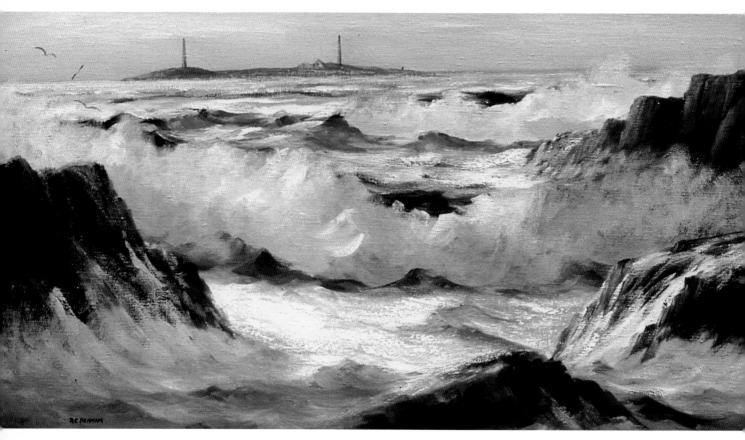

View of Thatcher, Robert C. Benham, oil, 24 x 48 inches

BETTE ELLIOTT

The product of a vibrant and easygoing spirit, Bette Elliott's work is some of the most exciting and eye-catching I've ever experienced. A master of color, Bette takes a loose approach to her work that has allowed her to become a versatile artist, proficient in many different styles. This openness to art and people enables her to be an excellent teacher. She's especially known for her abstract watercolors. Bette lives in North Canton, Ohio, and her works have been featured in the Butler Institute of American Art.

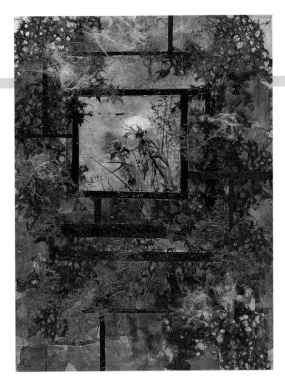

Ode to a Thistle, Bette Elliott, watercolor, 22 x 30 inches

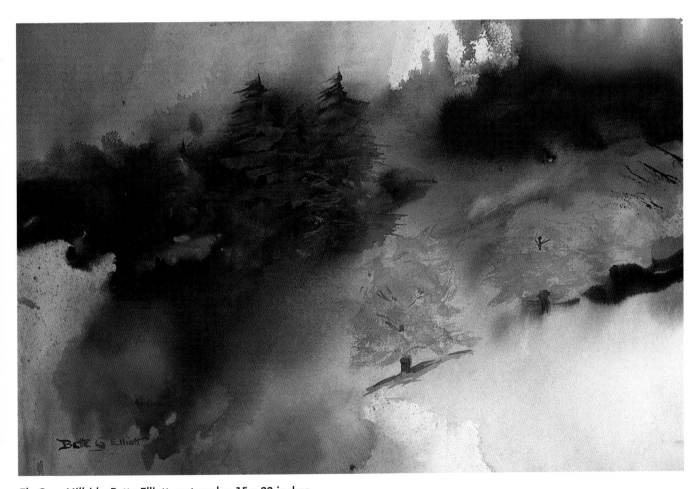

Fly Over Hillside, Bette Elliott, watercolor, 15 x 22 inches

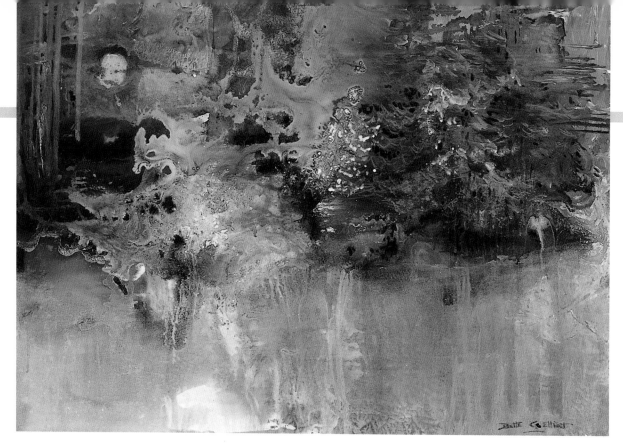

Night Snow, Bette Elliott,
watercolor, 30 x 40 inches

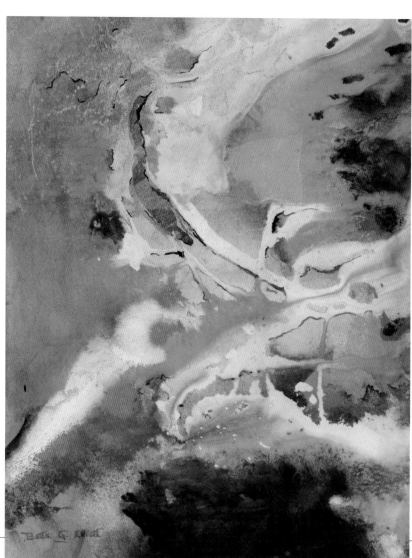

In Search Of, Bette Elliott,
watercolor, 16 x 20 inches

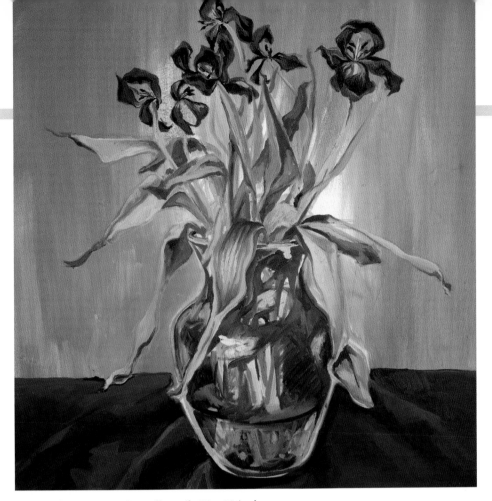

Captured Beauty, Jamie Hulley, oil, 35 x 38 inches

JAMIE ALAINE HULLEY

Jamie Alaine Hulley (1981–2002), from Orange, Connecticut, had a passion for the arts that she exhibited as a painter, writer, dancer, singer, songwriter, actress, and comedienne. However, while studying in Italy, lymphoma took away her childhood dream of pursuing a career as an artist. Although she passed away just two weeks short of her twenty-first birthday, she still left a legacy in art that reflected the fullness of her short life. She surely would have become a master of her craft had she been given the time. I honor her in this book for that which she achieved. Her friends and family and the Jamie A. Hulley Arts Foundation, a nonprofit organization dedicated to the support of young artists, also honor Jamie's creative passion. To see more of Jamie's work, log on to: www.jamiehulleyartsfund.org

Self-Portrait, Jamie Hulley, oil, 10 x 14 inches.
Courtesy of the Jamie A. Hulley Arts Foundation.

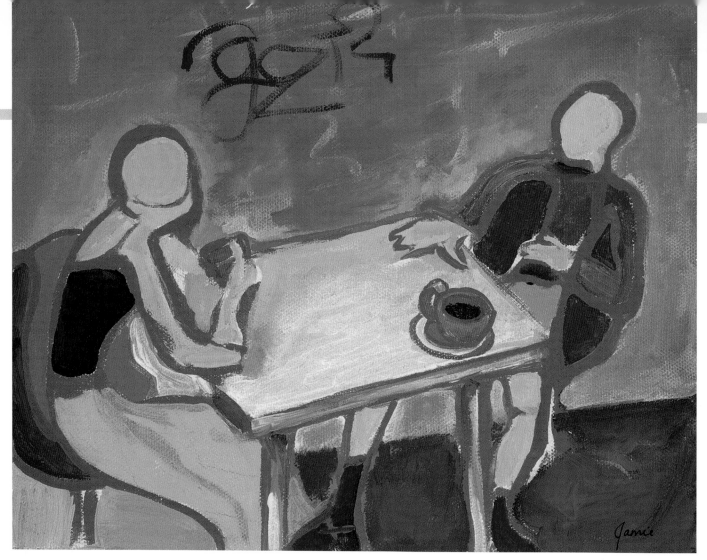

Coffee Conversation, Jamie Hulley, oil, 8 x 10 inches

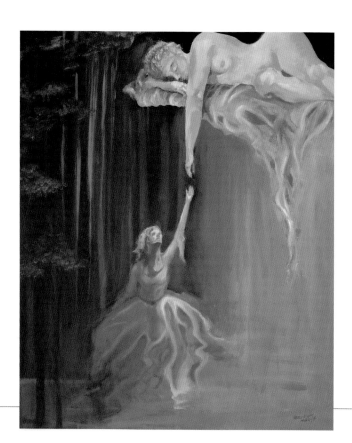

Renaissance Dream,
Jamie Hulley, oil,
20 x 24 inches

WILLIAM PERSA

"Long after the gimmicky fads of modern art are gone," **William Persa (1917–2002)** once said, "the magnificence of God's work honestly painted, will live on to please mankind." That philosophy guided Pennsylvania-born Persa during a long career that earned him over 100 awards and worldwide accolades.

He was a man of kind words and a gentle heart. His love of old things—"images of a gentler era," as one biography calls them—are greatly reflected in his paintings. William remains an inspiration to me, and his paintings always touch me with their use of colors, textures, movement, and realism.

A native of Bethlehem, Pennsylvania, William Persa graduated from the Philadelphia Museum School of Art and served as art director for advertising agencies in Atlanta, New York, and Allentown, Pennsylvania. He taught commercial art for nine years and retired in 1982 to paint full time, specializing in watercolors and pastels.

William's career began in fourth grade when he earned small sums for painting portraits in school. He continued to paint through the Depression and adolescence, college, and into his twilight years. His photo-realist presentation of what he saw in the face reflected the truth and beauty of people and objects. He treasured the loveliness and wonder of nature. Developing scenes slowly and deliberately, he created as much three-dimensional effect as possible, painting in minute detail, what he called "magna-vision," and sometimes taking as much as a month to complete a particular piece.

In his paintings we see rural scenes with birds, flowers, rusty farm implements, Indian corn, ropes, jugs, buckets, and more. He studied objects with acute awareness, matching colors, textures, lights and shadows, complex patterns, and hues to his perceptions. He wanted to preserve these things with a sense of nostalgia, joy of familiarity, and love of nature with the changing seasons and scenes. His works evoke serenity and calm.

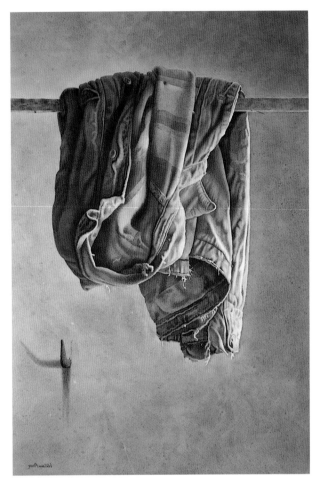

Pop's Jacket on Rail, William Persa, oil, 20 x 30 inches

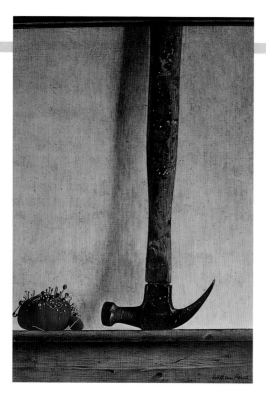

Man and Woman, William Persa, oil
11 x 15 inches

Man with a Feather, William Persa, oil, 30 x 38 inches

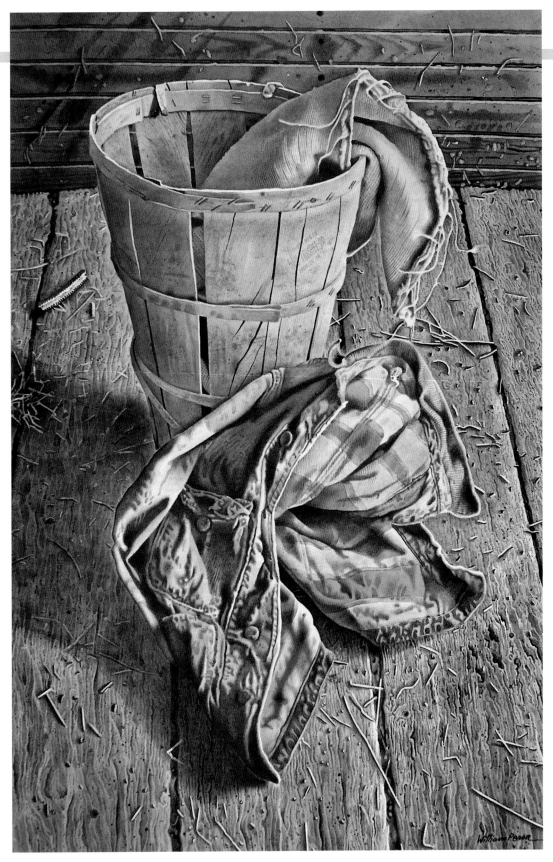

Pop's Jacket #5, William Persa, oil 22 x 30 inches.
Photos are courtesy of William Persa's daughter, Susan Repic.

Pueblo Woman, **James Penland**, acrylics, 30 x 40 inches

JAMES PENLAND

Born and reared in Lakeland, Florida, **James Penland's (b. 1931–)** art career began as a young man creating murals and yearbook art as well as participating in community art projects. Penland, an accomplished musician, performed in municipal concerts as well as performing solos as a trombonist with the Barnum & Bailey Circus Band. He attended Florida Southern College and Temple University's Tyler School of Art in Philadelphia. After moving to New Jersey, he opened the Penland School of the Arts in Atlantic City, where his sideline was as a Boardwalk portrait artist. Seeing the need for a center for artists' works in the area, he formed a gallery with other artists. This association led to the formation of the Atlantic City Arts Center on Garden Pier. Its first masquerade ball, attended by over 1,400 people, cemented this art center as a vital component of the Atlantic City community.

In Ocean City, New Jersey, Jim opened three stores and helped form the Ocean City Fine Arts League Boardwalk Art Show. This show has thrived for over forty years.

As an active member of various art leagues and associations, Jim paints in a wide range of media and continues to teach and take portrait commissions. His works have been included in private and public art collections around the world.

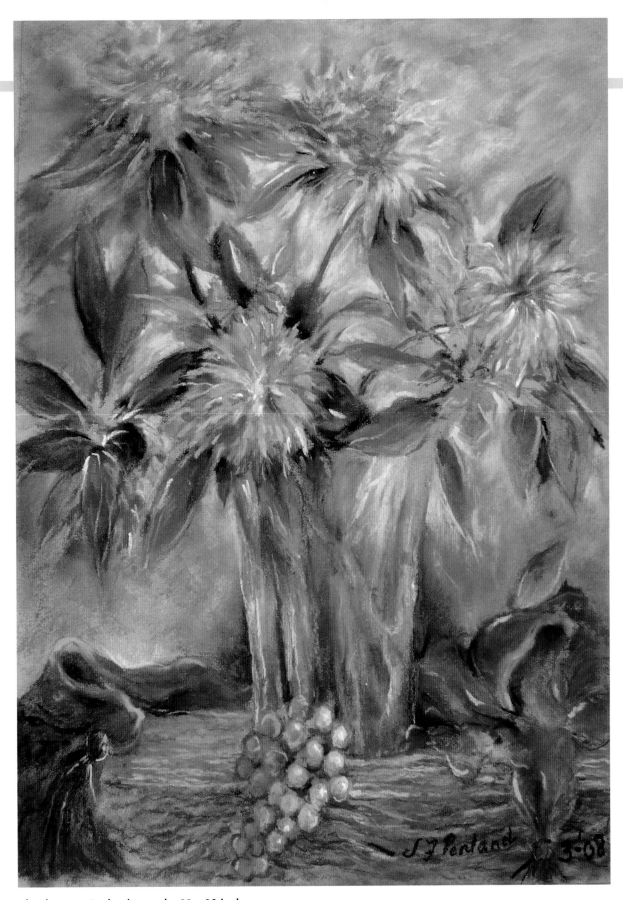

Floral, James Penland, pastels, 22 x 30 inches

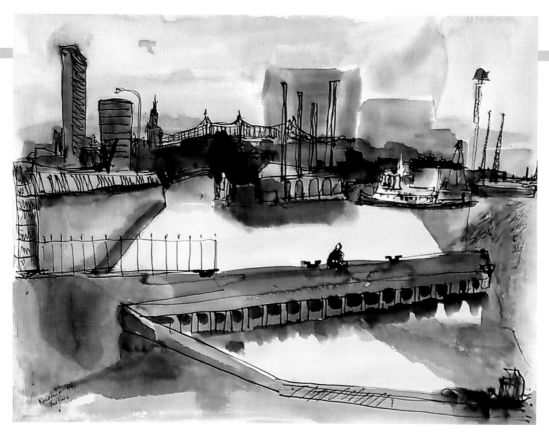

East River, Joe Kardonne, acrylics, 15 x 22 inches

JOE KARDONNE

Born in Newark, New Jersey, **Joe Kardonne (1909–2005)** began his artistic career at age 15, when he painted murals for a large department store in his home city. He studied art at the Faucet Art School and the Art Students League in New York with Cameron Booth, Byron Brown, Thomas Howard Trafton, B. Robinson, and other renowned artists. He was strongly influenced by Thomas Hart Benton. His active professional life included operating Kardonne Advertising Agency in New Jersey. In 1986 Joe retired to Ocean City, New Jersey, where he set up a studio.

His works have been widely exhibited in museums, galleries, and shows in the northeastern United States. He enjoyed painting watercolors with urban street scenes, European streets and landscapes, and marine scenes. He also was known for pen-and-ink drawings and oils painted in an impressionistic style. He reveled in free-flowing forms and bright colors.

In the 1990s, Joe said, "In my present phase I am using a more abstract point of view, composing pictures with shapes, lines, and colors, instead of illustrating the world. I am using whatever inspires me to see shapes, forms, colors, and patterns. Whatever comes out is left to the imagination of the viewer....Being drawn into the painting makes it a more personal, imaginative, and interactive experience for the viewer."

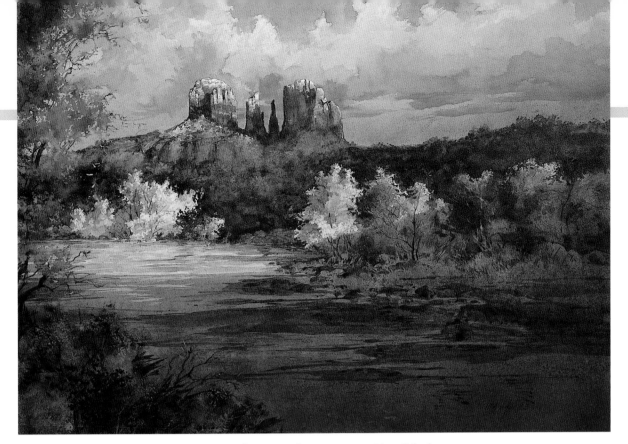

Lavender Skies (Sedona, Arizona), Tom Lynch, watercolor on canvas, 30 x 40 inches

TOM LYNCH

When I met **Tom Lynch (b. 1950)** about twenty years ago at a workshop in Chicago, I was very impressed not only with his painting skills but with his tremendous teaching ability. Students all over the world have sought out his classes.

Tom has always exhibited enthusiasm for the creative process and has never had trouble sharing that with others. I admire his ability to create a masterpiece in a short time. Whether Tom is painting a sparkling winter day, secluded woods, or turbulent sky, he can capture that atmosphere on paper. His paintings are infused with a romantic quality, unusual and dramatic lighting, and capture a moment of nostalgia while aware of the passing of time.

In his paintings, Tom anticipates the next feeling, the next mood, the next subject. As he explains, "To acknowledge my dreams and give them validity, I take action." As with most great artists, Tom can bring out the extraordinary qualities of an ordinary subject. This is his quality that I admire the most.

Tom is a natural teacher who capably helps students develop their work based on each student's own individual needs.

In his award-winning PBS television series and numerous videos, he has been happy to share his expertise and knowledge. He has written six books on watercolor, and his latest book comprising 100 workshop lessons, *Tom Lynch's Watercolor Secrets,* has received international acclaim for its unique design. Among his numerous credentials are two lifetime achievement awards, election to the illustrious Society of American Impressionists, *Who's Who in American Art*, and signature memberships in many national watercolor societies.

For Tom, painting is a passionate commitment to looking at and capturing a personal experience from the landscape. His paintings express the moods and feelings of the place. They are more about the expression rather than the physical description of the subject matter.

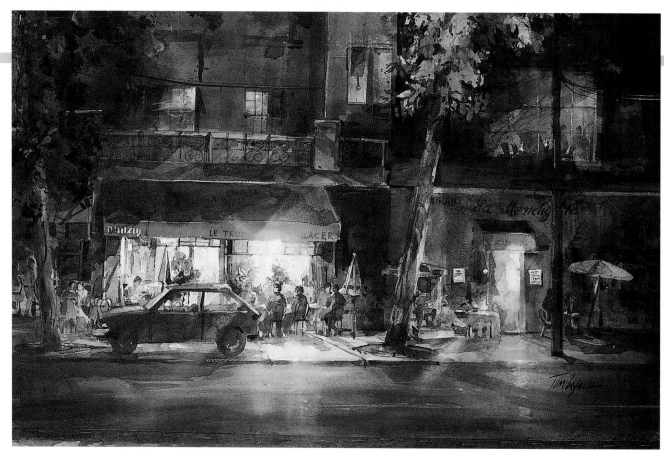

Night Café (Paris), Tom Lynch, watercolor on paper, 22 x 30 inches

right **French Wine Shop** (Paris), Tom Lynch, watercolor on canvas, 24 x 36 inches

far right **LaSalle St.** (Chicago), Tom Lynch, watercolor on canvas, 24 x 36 inches

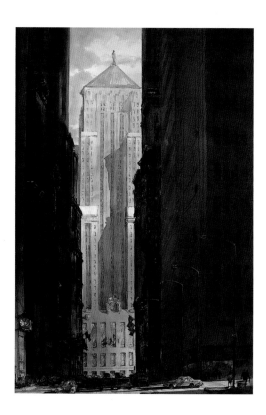

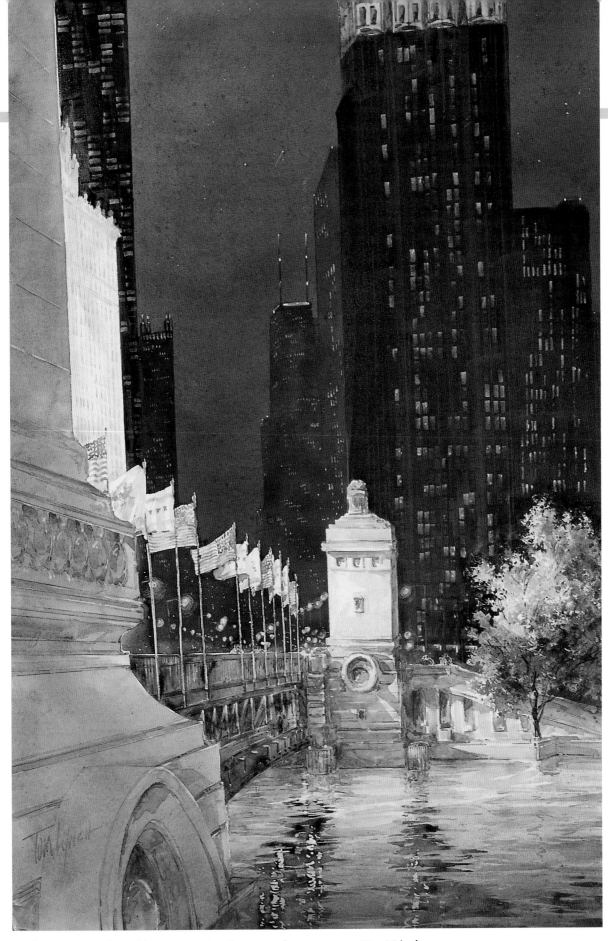

Michigan Ave. Bridge (Chicago), Tom Lynch, watercolor on canvas, 24 x 36 inches

Painting Watercolor on Canvas

Tom Lynch shared with me the primary benefits of painting on watercolor canvas, and you may be as enthusiastic as I was to try it. Painting on canvas can bring many things to the painter; the color is brighter and more alive than when painting on standard watercolor paper. Tom describes the easy-lifting power that enables the artist to render shimmering lights with just a lift of color, an easy way to add highlights, stronger contrast, and so many more positive effects. Here's his technique.

Wet the canvas with a damp towel and place it on your board. You do not need to tape the canvas down; it will adhere to the board. You can do your drawing while the canvas is still wet. (You don't need to stretch the canvas as you would when preparing it for an oil painting.)

Keep in mind that the canvas does not absorb the color the way that watercolor paper does, so your first application should be thicker, with almost full-strength watercolor. Have no fear because the color can be completely lifted if you've made a mistake.

Allow the first wash to dry and apply a lather of color over the original color; do not press as hard as you would on watercolor paper because of the easy lift on canvas. The wonderful thing about the easy-lifting power of canvas is that you can go back in with a small brush and make waves come alive with just a lift of color or turn

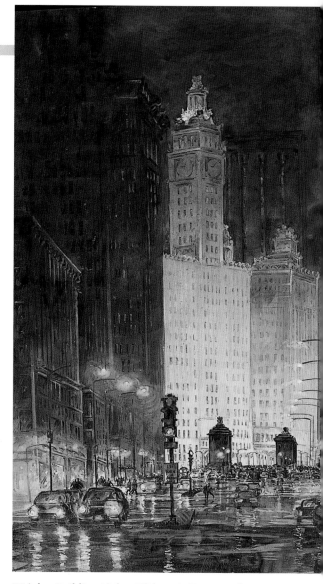

Wrigley Building Lights (Chicago), Tom Lynch, watercolor on canvas, 24 x 36 inches

an ordinary shadow into a sparkle of light. The possibilities are endless….

When you are happy with your painting, spray it with an acrylic fixative, and you're ready to hang it! No more waiting for the paint to dry in six months as usually happens in oil painting. Thank you, Tom, for another great lesson!

Fredericks makes watercolor canvas.

What to Do

In the beginning, the most important advice I give to students is to be positive. If you think you can, you will. If you think you can't, you probably won't. Eleanor Roosevelt said, "The future belongs to those who believe in the beauty of their dreams." Take heed and follow your dreams. Expect obstacles along the way, but the results will be worth the ride.

When you begin mixing colors, you may get very frustrated with all the pigments at your disposal. You may ask yourself: what colors do I use to produce vibrant results? What is a vibrant red, a peaceful green, or a subdued yellow? Numerous questions can plague your mind when you first begin to work with color.

Most painters begin with the thought that we can just jump in with all the colors available to us and apply them to paper at will. We believe they will somehow work together as we expect them to. However, we'll soon become disillusioned with those hastily achieved results.

Knowing how the color wheel works can be a good way to begin. If we start putting pigments on the paper without knowing what chemicals we are using and mixing, we are going to feel as though we are in the dark about color.

Be informed about color and all its possibilities. Do not assume anything about how the colors will react together. This is a premature judgement and could cause disillusion.

Rules can serve as guides, and it's good to understand them. After you have full command of the medium, you may be able to successfully break them.

"What lies behind us and what lies before us are tiny matters compared to what lies within us," essayist Ralph Waldo Emerson (1803–1882) said.

ARE YOU WILLING TO TAKE THE RISK?

Everything we do in life involves risk-taking. If we do not take chances when painting, we will run the risk of never maturing as artists but instead staying closed up inside ourselves.

Reach for the sky, set goals, and be your best self. Let go of ego, and do not be afraid of others' critiques.

Remember, everyone begins somewhere. Ask for guidance, explore all possibilities, read a lot, paint a lot, and be good to yourself.

There will be hard times, but the hard times bring out the best in you. They make you suffer a little, and sometimes you will be so tired that you may feel as if you just cannot pick up that brush and paint another stroke. Take a nap and refresh your mind. Then get back to painting.

Dare to dream, explore, investigate, study.

This may sound like a lot of work, but the results will not only make you a better artist, they will make you a better person. Be sure to cheer on fellow artists' achievements; you will learn humility. Think positive thoughts and you will be filled with pride in what you have accomplished.

The masters all were overachievers. Take the risk.

Notes on the Physics of Color *from* Ian Albert

Light, whether visible or invisible (infrared, ultraviolet, radio waves, X-rays, etc.), acts like a wave. Each photon, or particle, of light has a particular wavelength. The wavelength of visible light, what we can see as individual colors or part of the spectrum of a natural rainbow, falls into the 400 to 700 nanometer (nm) range. Light not found in the visible spectrum—ultraviolet, X-rays, and gamma rays—have shorter wavelengths, and infrared, microwaves, and radio waves have longer wavelengths.

White light consists of all colors—lots of different photons, red, violet, green, etc., with their particular wavelengths. What's interesting is that there are no brown photons or pink photons, nor are there any other colors that consist of multiple wavelengths together. Each photon has a single designated wavelength.

How do we see color? When white light falls on red watercolor pigment, most of the photons are absorbed; that is, they collide with the pigment and are converted to a tiny amount of heat. A portion of the red photons reflects off the surface, so we see the pigment as "red."

A full-spectrum lamp, whether incandescent or fluorescent, produces a more or less uniform intensity of light across the entire visual spectrum, so it appears white. The so-called lunar white from "white" light-emitting diodes (LEDs), found in remote controls and digital clocks, consists of two light sources: one blue and one yellow. Since the yellow light stimulates the eyes' red and green receptors, the mix of blue and yellow light gives the appearance of "white." Since the colors are complements, they appear together as white. However, because the spectrum of each light source—the full-spectrum lamp and the LED—is so different, one with broad distribution and two with fairly narrow colors, the watercolor paint pigments they illuminate may appear quite different under each light source.

Color is a rather elusive property. To our eyes, color is the sum of how much red, green, and blue light hits the cone cells in the retina. We can represent color as a plot of frequencies (wavelengths) rather than intensity. Say, a particular watercolor paint pigment reflects 50% of 520 nanometers light, 60% of 540 nanometers of light, 60% of 560 nanometers of light, and so on of all visible and invisible wavelengths, forming a complex curve. Our eyes only discern light that's in the red, green, and blue visible range, however.

Unlike printer's CMYK (cyan, magenta, yellow, and black) inks, with precise spectra to absorb light of particular wavelengths, watercolor paint pigments are not designed to mix purely. Cyan ink absorbs red light, magenta ink absorbs green light, and yellow ink absorbs blue light. The inks are made so that the range of wavelengths each absorbs overlaps as little as possible, thus producing the most accurate color combinations. While watercolor pigments are formulated to appear a certain shade, they are not engineered for precise mixing, so their spectral absorption may overlap or may seem to have large gaps between two given colors.

But don't envy the printer. As any publisher will tell you, printer's CMYK inks are limited to about 24,000 different colors, so it is impossible to achieve the subtlety and purity of what we see in nature. Remember that they cannot achieve the brilliance and luminosity of your original watercolors. Other printer's inks work on the RGB (red, green, blue) colors used on computer monitors, and they, too, can be tricky.

A Color Glossary

analogous colors Colors found next to each other on the color wheel.

background The background of a painting is the part farthest away from view, such as the sky serving as the background for a landscape.

bias All colors can be biased toward another color. A red could be warm or cool. For instance, carmine or crimson lake (a red watercolor pigment) is considered a cool red because it has a bias toward blue, or simply a "blue bias." Cadmium red is considered a warm red because it has a bias toward yellow. Another term for bias is *undertone*.

blending Using one or more brushstrokes to fuse two color planes together so that no sharp divisions are discernible.

blotting Using an absorbent material, such as a tissue, paper towel, or a squeezed-out brush, to pick up and lighten a wet or damp wash. This technique can be used to lighten large areas or to pick out fine details.

cast shadow When a source of light is intercepted by an object, a dark area results beside that object.

color wheel A circular graphic device that shows color relationships and placements.

complementary colors Colors found at opposite points on the color wheel. Examples of complements are red and green, yellow and purple.

compound colors The mixture of three primaries to create an earth-tone or browns, grays, and blacks.

dry brush Any textured application of paint where the brush is fairly dry (thin or thick paint) and you rely on the hairs of your brush, the angle of attack of your stroke, and the paper's surface texture to create broken areas of paint. Used for rendering a variety of textured surfaces: stone, weathered wood, foliage, lakes and rivers, bark, and clouds.

flat wash Any area of a painting where a wash of a single color and value is painted in a series of multiple, overlapping stokes following the flow of the paint. A slightly tilted surface aids the flow of washes. The paper can be dry or damp.

focal point The element of a design where lines converge. The eye is naturally drawn to the focal point in an image.

foreground The area of a painting closest to the viewer. In a landscape this would include the area from the viewer to the middle distance.

fresco Meaning "fresh" in Italian, fresco is the art of painting with pure pigments ground in water on uncured (wet) lime plaster. It is an ancient technique used worldwide by artists of many ages and cultures. Michelangelo's Sistine Chapel ceiling is a famous example of fresco painting. Durability is achieved as the pigments chemically bind with the plaster over time as it hardens to its natural limestone state.

fugitive colors The pigments in the "fugitive" class of paints have the unfortunate characteristic of looking beautiful and unique when first painted but show undesirable side effects over time. Side effects include fading to nonexistence, changing color, darkening even to black, and other disappointing results due to a chemical change. Unless you're planning on hermetically sealing your paintings and viewing them in a low-ultraviolet-light, climate-controlled room, skip them. Use lightfast ratings I and II when possible.

glazed wash Any transparent wash of color laid over a dry, previously painted area. The glaze is used to adjust color, value, or intensity of an underlying painting.

graded wash A wash that smoothly changes in value from dark to light across a surface. This is most often used in landscape painting for open sky work, but it's an essential skill for watercolor painting in general.

highlight A point of intense brightness, such as the reflection in an eye.

hue The color of a pigment or an object, unrelated to its tone or value.

intensity The strength of a color based on how true it is to the primary color.

key The lightness (high key) or darkness (low key) of a painting.

light refraction Light bent through a prism that shows the colors of the light spectrum visible to the human eye: red, orange, yellow, green, blue, indigo, and violet (ROYGBIV).

local color The actual color of an object being painted, unmodified by light or shadow. (An orange is orange.)

modeling Representing color and lighting effects to make an image appear three-dimensional.

monochromatic color scheme Uses different values of the same color.

muted colors Subdued tints or shades of colors that tend to be more suitable for backgrounds.

negative space The areas of an artwork that are not occupied by a given subject or object. Negative space defines the outline of the subject but does not flesh it in. (Think of what would remain if the shape itself, say a butterfly, were cut out of the painting.)

nonstaining colors Pigments that can be lifted cleanly (wet or re-wet) with little or no discoloration of the underlying paper fibers.

opaque A paint that is not transparent and not translucent. A dense paint that obscures or totally hides the underpainting in any given artwork.

perspective Representing three-dimensional volumes and space in two dimensions in a manner that imitates depth, height, and width as seen in stereo (with two eyes).

positive space The areas in an artwork occupied by the fleshed-out subject or object (often the principal subject).

primary colors Red, yellow, and blue, the mixture of which will yield all other colors in the spectrum but which themselves cannot be produced through a mixture of other colors.

saturation The use of paint from the tub undiluted with much water.

secondary colors Colors created by blending primary colors. Orange, green, and violet are the secondary colors created by mixing a combination of red, yellow, and blue.

shade A color with black added to it.

staining colors Colors that cannot be fully removed from your paper. Staining colors permeate the fiber of the paper and leave a permanent tint. Check your hands after painting; the hardest colors to wash off are usually the staining colors.

tertiary colors Also called *intermediate colors,* these are blends of primary and secondary colors. Colors such as red-orange and blue-green are tertiary colors.

texture The actual or virtual representation of different surfaces, whether rough, smooth, bumpy,

mottled, soft, or hard. Paint applied in a manner that breaks up the continuous color or tone.

tint A color that has had white mixed in.

tone The light and dark values of a color.

triadic colors A group of three colors that form a triangle on the color wheel.

undertone Another word for bias of one color toward another.

values The relative lightness or darkness of colors or of grays.

variegated wash A wet wash created by blending a variety of discrete colors so that each color retains its character while blending uniquely with the other colors in the wash.

vignette A painting that is shaded off around the edges leaving a pleasing shape within a border of white or color. Oval or broken vignettes are very common.

wash A transparent layer of diluted color that is brushed on.

watercolor Painting in pigments suspended in water and a binder such as gum arabic. Traditionally used in a light to dark manner, using the white of the paper to determine values.

wet-on-wet The technique of painting wet color into a wet surface (paper saturated). Contrast with dry-brush application of paint.

Acknowledgments

I WANT TO THANK THOSE IN MY LIFE who have added encouragement and support to me all these years to make this book a reality.

Jeanette Green, my editor, who has been there through good times and bad, constantly pushing me to be a better writer, and who so soothingly called me to be the writer I am today. You are the best.

Charles Nurnberg, who believed in me and made me realize my potential. Sterling and Barnes & Noble for supporting all my books.

My brothers, Jim and John Swartz, who are accomplished authors, for encouraging me to continue writing.

Dick Rogers for the absolutely beautiful photography that enhances this book. My friend, Gary Brown, I thank for his insight. Shella Marzich for being so organized when I was frustrated; you are one gifted lady.

Margaret LaSalle for answers to my numerous questions; you are a jewel.

Maurice Oatley, whose early guidance brought me a long way; thank you.

Ian Albert for his incredible knowledge of color and allowing me to share with all of you this wonderful gift. Kudos to you, Ian, you've taught me so much. I am so happy that there are people like you who give freely of themselves and open our minds to the world of color. Thank you.

Bill Johnson, whose help with finals was priceless.

Many thanks to contributing artists Patricia Bagueros, Bill Johnson, Phyllis Amato, Kris Wyler, Carol Pershing, Mary Nieto, Giovanna Nicandro, Gary Brown, and to Susan Repic, daughter of artist William Persa, and the parents of artist Jamie Hulley.

My teachers and mentors, who believed in me an inspired this endeavor: Skip Lawrence, Don Stone, James Penland, William Persa, Robert C. Benham, Bette Elliott, Joe Kardonne, Helen Van Wyk, Andrew Wyeth, Tom Lynch, and to everyone who graciously allowed me to use their work to make this book more wonderful.

All my friends and traveling companions in Italy, thank you for great laughs and fun times. It was a lovely experience; I am blessed by the experience of your presence.

The support of family and friends goes beyond measure. Without them there would not be a me. They made me the person I am today. It has not always been easy for them, and I thank them for being there with their love.

Last, but not least, my mom, who still sits on my shoulder guiding my hand. There are not enough words to express my gratitude for her unconditional love. Wherever she is, I thank her. Mom, please stay on my shoulder and keep guiding me.

—*Marcia Moses*

Index of Paintings and Artists

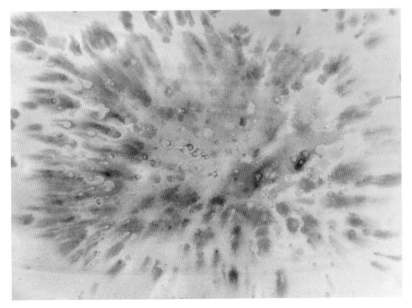

Splashes of Color,
Marcia Moses, 11 x 14 inches

General Index

About the Author

Author and artist Marcia Moses began working with oils but soon fell in love with watercolor. Since 1989, Marcia has taught watercolor workshops and led motivational seminars across the United States and Canada. Her watercolors have been exhibited in galleries and private collections all over the world. She has been recognized in *Who's Who in American Art* and is a member of the American Watercolor Society, the Ohio Watercolor Society, and the North Shore Arts Association of Gloucester, Massachusetts. Her first book, *Easy Watercolor: Learn to Express Yourself* (Sterling, 2002), won a Gold Ink Award and was named in the American Library Association's *Booklist* among the top ten hobby and craft books of 2003. Marcia's second book, *Creative Watercolor: New Ways to Express Yourself* (Sterling, 2005), is geared toward the intermediate watercolor student. Marcia was educated in art at Kent State University and The Ohio State University. She lives in Canton, Ohio.